LE MANS
WINNING COLOURS

A VISUAL HISTORY OF 100 YEARS OF THE 24-HOUR RACE

MICK HILL

FOREWORD BY
MARK BLUNDELL

First published 2023. The History Press, 97 St George's Place, Cheltenham, Gloucestershire, GL50 3QB www.thehistorypress.co.uk
© Mick Hill, 2023

The right of Mick Hill to be identified as the Author of this work has been asserted in accordance with the Copyright, Designs and Patents Act 1988.
All rights reserved. No part of this book may be reprinted or reproduced or utilised in any form or by any electronic, mechanical or other means, now known or hereafter invented, including photocopying and recording, or in any information storage or retrieval system, without the permission in writing from the Publishers.

British Library Cataloguing in Publication Data. A catalogue record for this book is available from the British Library.
ISBN 978 1 80399 201 3
Typesetting and origination by The History Press. Printed in Turkey by IMAK

CONTENTS

Foreword	4
Introduction	5
History	6
Key to Graphics	7
Map	8
1923–1929	10
1930–1939	19
1949	30
1950–1959	32
1960–1969	46
1970–1979	58
1980–1989	70
1990–1999	82
2000–2009	94
2010–2019	106
2020–2023	118
Records	122
Track Changes	124
Witness	126
Deaths	127
Acknowledgements	128
Credits	128

FOREWORD

It is an honour and privilege to be writing this foreword for such a special book that celebrates one of the biggest motorsport events in the world. The fact that the 100th anniversary is upon us and I sit today, glancing across the room, looking at my 24 Hours of Le Mans winner's trophy, makes this even more fitting for me.

When you mention the 24 Hours of Le Mans in conversation, it stirs emotions and memories with racing drivers, team members and fans alike; there is no bigger test for manufacturers, teams and for me personally than competing and completing the most feared endurance motoring event on the globe.

I am immensely proud of my 24 Hours Le Mans victory and I don't know too many racing drivers who would turn down being part of this iconic race, steeped in history. This is where Mick, through the most detailed illustrations, will take us year by year down memory lane celebrating those race-winning cars that have achieved one of the most prestigious awards to be gained in motorsport.

The journey *Le Mans Winning Colours* takes you on will show the evolution of the Le Mans racing car and the designs and technology that have progressed across the years, along with the manufacturers that have been so successful at this test of durability and speed across twenty-four hours of time.

I hope you enjoy this wonderful book as much as I did.

Mark Blundell
1992 Le Mans winner

INTRODUCTION

When The History Press invited me to put this book together, it was not only an honour, but it also gave me an insight into a historic race spanning 100 years that I had only ever watched on TV and read about in the motoring press.

My interest in cars is from both a racing point of view and a technical perspective. As a technical illustrator by profession, I am interested in anything mechanical, but the cars that race at Le Mans really are in a class of their own. They are not only designed to last, but are a testament to the designers and personnel who work in the teams. The cars have to race flat out over a twenty-four-hour period at basically full throttle. To me, these cars are not just cars but masterpieces of technical engineering, each spending thousands of hours on the drawing board being designed and hours of wind-tunnel testing before they even turn a wheel on the track. The drivers are also a special breed, with the ability to stay awake from the start all the way through to the chequered flag twenty-four hours later. Illustrating all the winning cars from the 24 Hours of Le Mans and seeing how the car designs and speeds have changed dramatically in this 100-year time period, I often wonder what a driver from the 1920s would think if he could see these cars of today and the speeds they achieve!

I have tried to include as much information about the race, cars and results as possible, and even the weather conditions, from the records that were available. Producing this book really gave me a special understanding of the race and watching it in future will mean so much more to me.

HISTORY

The 24 Hours of Le Mans (French: *24 Heures du Mans*), organised by the Automobile Club de l'Ouest (ACO), held its first race in 1923 on the Circuit de la Sarthe, comprising closed public roads and dedicated sections of racing track. It was designed with endurance rather than pure speed in mind. Speed certainly plays a big part in motor racing, but not as much as being there at the finish; in the 24 Hours of Le Mans, the winning car is the one that covers the greatest distance in twenty-four hours.

The 24 Hours of Le Mans – normally held in June – concentrates on the technical ability of manufacturers to build fast and reliable cars. Traditionally, it began with what became known as the 'Le Mans start', whereby cars would line up along the length of the pits by engine capacity, until 1963 when qualifying times would determine the starting positions. When the flag dropped the drivers would sprint across the track to their cars, climb or jump in, start their cars and race away. In their haste to get away, many of the drivers would fail to put on their safety harness – some even running a few laps without it on – or would try putting it on while driving; the cars would also race in very close quarters in the opening laps. As a result, there were accidents and several deaths. Sadly, in 1969, British driver John Woolfe was killed when he crashed early in the race, as he was not wearing his seat harness. In the same race, however, Belgian driver Jacky Ickx, who had long been a critic of the Le Mans start, walked to his car when the flag dropped and fastened his harness before pulling away in protest over the poor safety requirements. Thanks to the actions of Jacky Ickx, and the tragic death of John Woolfe, the 1970 race started with the drivers seated inside their cars with their harnesses on and the engine off, waiting for the French tricolour to drop.

For many decades, except for refuelling, cars had to run for at least an hour into the race before they could pit to refill fluids such as oil or coolant – an attempt by the ACO to help increase efficiency and reliability. Teams who could not last the first hour without having to replace lost fluids risked disqualification. Another rule unique to Le Mans, which still applies today, was that cars had to be switched off while refuelling in the pits. This was certainly safer and less of a fire hazard, but it also provided another test of reliability, as the cars would need to restart many times under race conditions.

Not only are the teams competing for outright places in the race but, as they race in 'classes' or cars of similar specification, they are also looking to win their particular class. In recent times, competitors often cover well over 5,000km in twenty-four hours. The record set in 2010 was 5,410km, six times the length of the Indianapolis 500.

Key to graphic

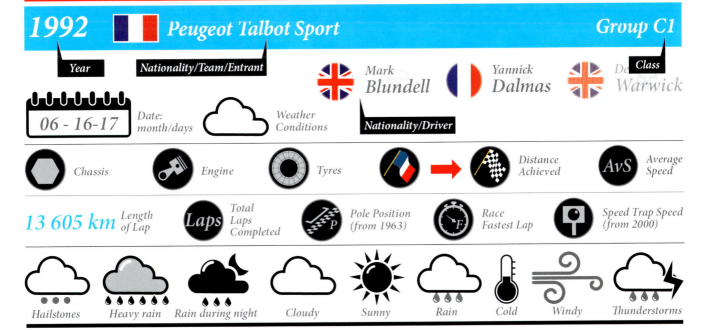

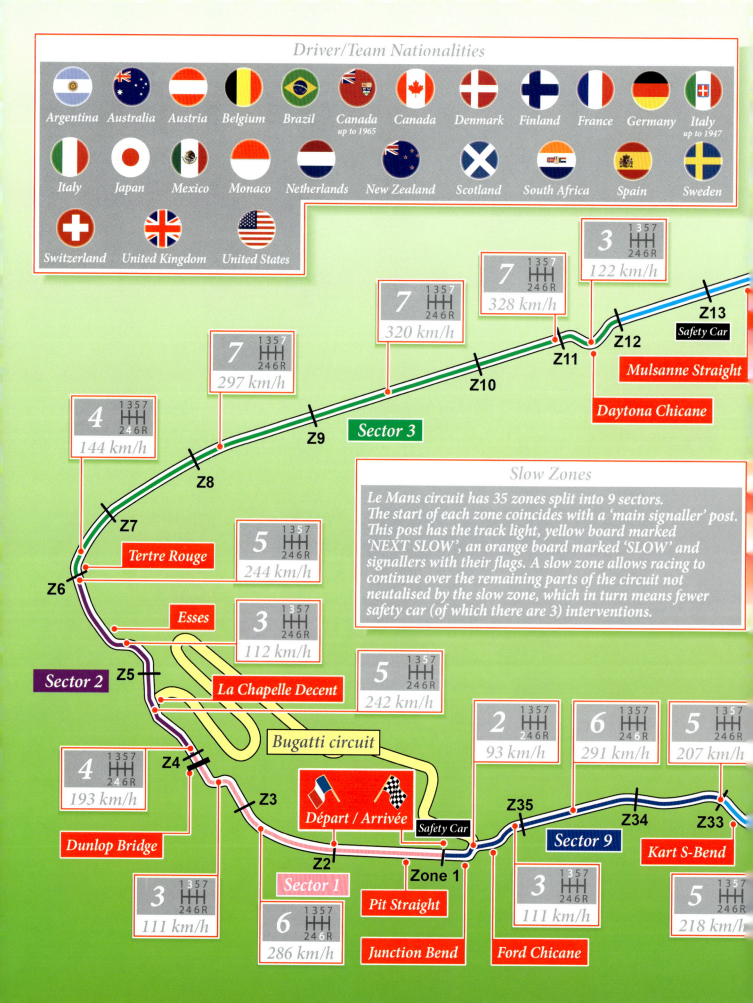

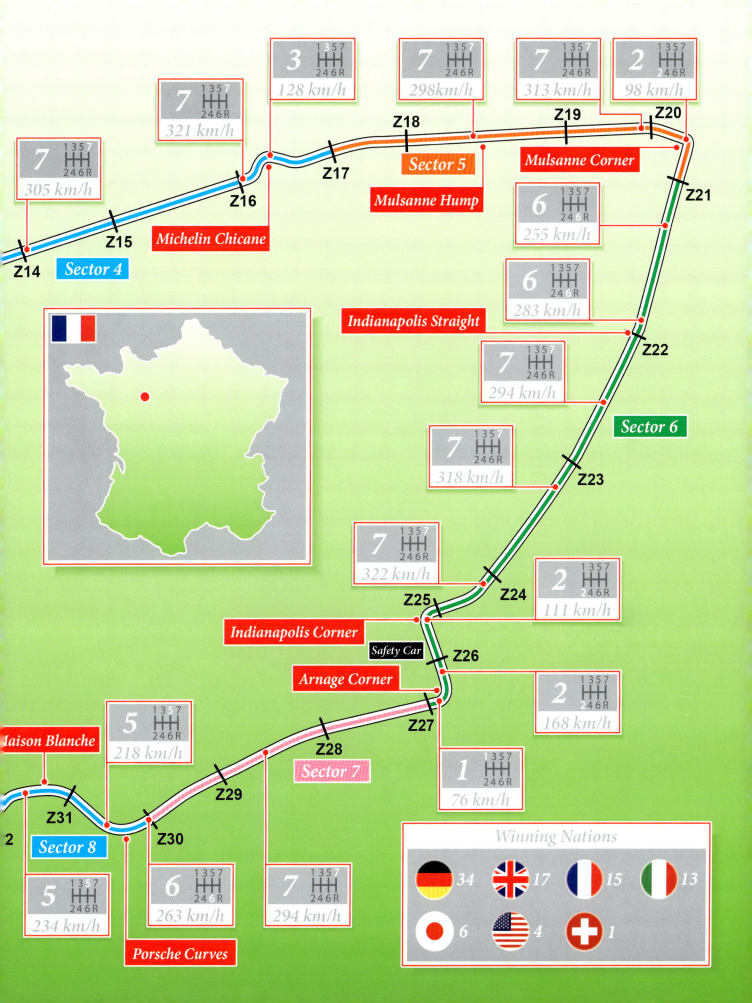

1923–1929

The first 24 Hours of Le Mans was only open to manufacturers. Thirty-three cars were entered from three different countries representing seventeen different marques. A violent hailstorm flooded the track the day before the start and covered it with layers of mud. For the race, wet conditions not only affected visibility but also caused problems with the headlights of many competitors. The only Bentley in the race began to experience brake problems and delays with problematic headlights, but it still managed to finish fourth and set the first lap record at Le Mans: 9:39, at an average speed of 107.328km/h. With only three retirements out of thirty-three cars, this record has not been broken to this day. Chenard & Walcker took the first two places in the race. The Rudge-Whitworth Triennial Cup was also established, which would be awarded to the best-ranked marque of the first three years of the race.

In 1924 the organisation changed the regulations, increasing the minimum distance from 82 to 119 laps (although this would be different for each class), and on lap five drivers had to stop in the pits and put their hoods up, which were to remain up for the next twenty laps. The Biennial Cup was also created to run parallel with the first Triennial Cup. The winner of the 1923 race, the Chenard & Walcker of André Lagache and René Leonard, set the pace. The average lap times were little affected even though the hoods were up, but there were thirteen retirements before the first twenty-five laps due to engine failures and accidents. On the twenty-sixth lap, the Chenard & Walcker set a new lap record of 9:19 before an engine fire ended its race. After twelve hours of racing the Bentley would take the lead, but on a routine stop for a tyre change, one of the wheel nuts could not be removed. After what would seem an age it finally left the pits and went on to win the race.

1925 saw the regulations require the sealing of several mechanical parts. The crank for the starter motor was prohibited in all electric ignition cars; there was to be a minimum of twenty laps between each top-up of fuel, water and oil; and a raised hood was mandatory for the start. The cars would line up in descending order of engine capacity and the drivers started the race on the opposite side of the track, running to the cars, before racing away: the famous Le Mans start was born, which would continue until 1969.

The 1926 competition regulations saw a rise in the averages, and the classification by performance index was born, which rewards the car that covers the greatest distance depending on the type of vehicle, its cubic capacity and its age. At night the tribune area would be lit up, with the lights being turned on at 8 p.m. and turned off at 6 a.m. The first loudspeakers were also used around the circuit. The second-placed Lorraine-Dietrich set the fastest lap: 9:03 at an average of 114.444km/h. The winning Lorraine-Dietrich exceeded the 100km/h average time barrier, with André Rossignol and Robert Bloch behind the wheel. The team also obtained the world record for the distance covered in twenty-four hours – 2,552.141km.

With the regulations becoming even tighter in 1927, the first twenty laps continued to be run with the hoods up. The organiser would now supply all competitors with a single type of gasoline, ECO gasoline. Only the spares carried on board the competing car could be used for repairs. The Bentleys took control from the outset but after various mishaps they were to find themselves lower down the rankings. However, on the last day, at 2:28 p.m., the leading French team came to a halt with a broken distributor and Bentley took its second victory at Le Mans, with its driver Frank Clement setting a new lap record for the circuit of 8:46. The first competitor with front-wheel drive, a Tracta, finished in seventh place.

To increase the number of 1928 entries, the registration fees were reduced and the mandatory twenty laps of the cars running with the hoods up was scrapped. A new lap record was set at 8:07 by Henry Birkin in the Bentley, which finished fifth overall. Alfa Romeo did not pass scrutiny, as it was considered 'too sporty' and therefore did not comply with the 'comfortable' rule that the cars had to be more like those sold to the public.

The first change in the circuit's layout came in 1929, when the distance was reduced by 922m to 16,340km. Cars that did not make the minimum distance imposed at the twelfth and twenty-fourth hour were automatically eliminated. The new Bentley Speed Six won with Woolf Barnato and Birkin at the wheel, with the distance covered exceeding 2,843km; the average rose to 118.492km/h, with the lap record dropping to 7:21 (due in part to the circuit being reduced by 922m).

1923 *Chenard-Walcker* *2000 - 3000cc*

 André *Lagache* René *Léonard*

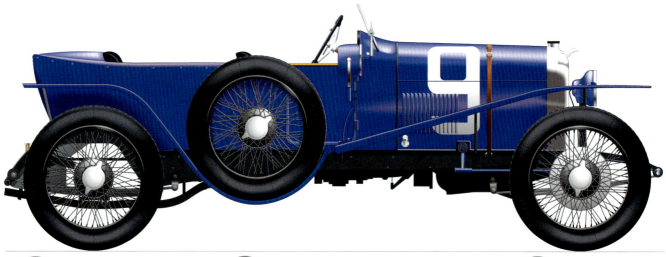

Chenard-Walcker Type U3 15CV Sport Chenard-Walcker 3.0L S4 Michelin

 05 - 26-27

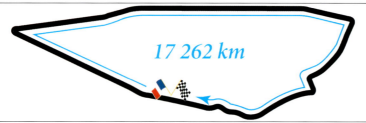 17 262 km

 → 2209.536 km

Laps 128 **AvS** 92.064 km/h

 Frank Clement, Bentley Sport 9'39" 107.328 km/h

Other class winners	Drivers	Car
5000 - 8000 cc	André Dills / Nicolas Caerels	Excelsior
3000 - 5000 cc	Gérard de Courcelles / André Rossignol	La Lorraine-Dietrich
1500 - 2000 cc	Raymond de Tornaco / Paul Gros	Bignan
1100 - 1500 cc	Max de Pourtales / Sosthene de la Rochefoucauld	Bugatti
750 - 1100 cc	Lucien Desvaux / Georges Casse	Salmson

2000 - 3000cc — Duff & Aldington 1924

 John *Duff* Frank *Clement*

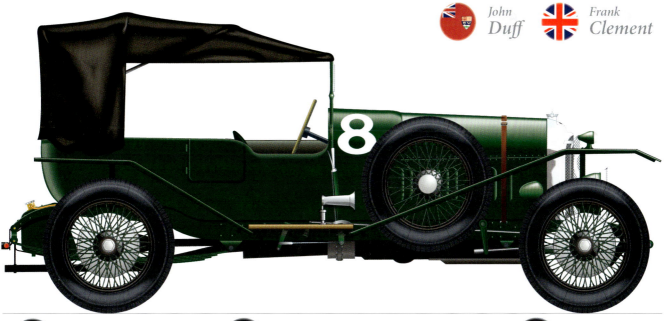

Bentley 3 Litre Sport Bentley 3.0L S4 2995cc Repson

06 - 14-15

17 262 km

2077.340 km
Laps 120 AvS 86.555 km/h

André Lagache, Chenard Walcker
9'19" 111.168 km/h

Other class winners	Drivers	Car
3000 - 5000 cc	Henri Stoffel / Édouard Brisson	La Lorraine-Dietrich
1500 - 2000 cc	André Pisard / Chavée	Chenard & Walcker
750 - 1100 cc	Fernand Gabriel / Henri Lapierre	Ariés

1925 Société Lorraine De Dietrich et Cie 3001 - 5000cc

 Gérard *de Courcelles* André *Rossignol*

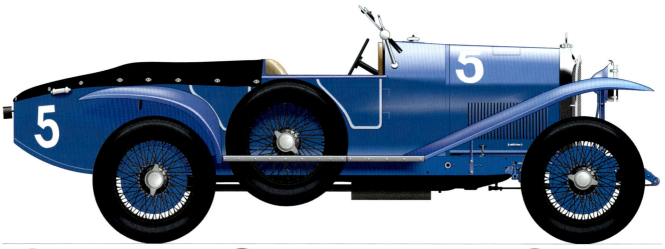

 Lorraine-Dietrich B3-6 Sport Lorraine-Dietrich 3.5L S6 2473cc Englebert

 06 - 20-21

 17 262 km

 → 2233.982 km

 Laps 129 AvS 93.082 km/h

 André Lagache, Chenard Walcker 9'10" 112.987 km/h

Other class winners	Drivers	Car
1st Triennial Cup	R. Sénéchal / A Loqueneux	Chenard & Walcker
1st Biennial Cup - Index of Performance (Rudge-Whitworth Cup)	R. Glazsmann / M. de Zuniga	Chenard & Walcker
2001 - 3000 cc	J. Chassagne / S.C.H. Davis	Sunbeam
1501 - 2000 cc	J. de Marguenat / L. Sire	Rolland-Pilain
1101 - 1500 cc	L. Balart / R. Doutrebente	Corre La Licorne
751 - 1100 cc	R. Glazsmann / M. de Zuniga	Chenard & Walcker

3001 - 5000cc *Société Lorraine De Dietrich et Cie* 1926

 Robert **Bloch** *André* **Rossignol**

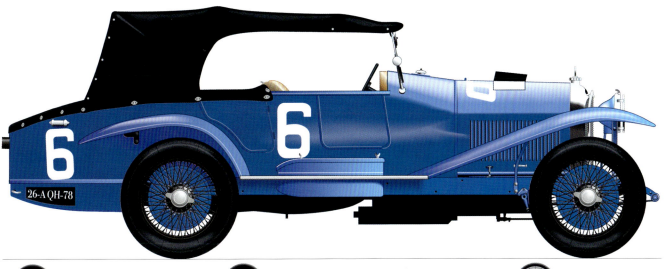

Lorraine-Dietrich B3-6 Sport Lorraine-Dietrich 3.4L S6 3446cc Dunlop

06 - 12-13

17 262 km 2552.141 km Laps 148 AvS 106.350 km/h

Gérard de Courcelles, Lorraine Dietrich B3-6
9'03" 114. 444 km/h

Other class winners	Drivers	Car
2nd Biennial Cup - Index of Performance (Rudge-Whitworth Trophy)	N. Minoia / G. Foresti	O.M.
1501- 2000cc	N. Minoia / G. Foresti	O.M.
1101 - 1500cc	de Costier / P. Bussienne	EHP
751 - 1100cc	G. Casse / A. Rosseau	Salmson

1923-1929

1927 🇬🇧 Bentley Motors Ltd. 2000 - 3000cc

🇬🇧 Dudley *Benjafield* 🇬🇧 Sammy *Davis*

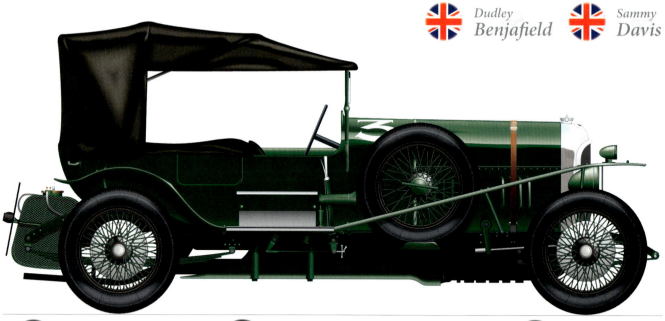

 Bentley 3 litre Speed Bentley 3.0L S4 2941cc Dunlop

 06 - 18-19

 17 262 km

 → 2369.807 km

 Laps 137 AvS 98.740 km/h

 Frank Clement, Bentley "Super Sport" 8'46" 118.142 km/h

Other class winners	Drivers	Car
3rd Biennial Cup - Index of Performance (Rudge-Whitworth Cup)	G. Casse / A. Rousseau	Salmson
Prix le Saint-Didier *(50 000 F in cash)*	A. de Victor / J. Hasley	Salmson
1100 - 1500 cc	L. Desvaux / F. Vallon	SCAP
750 - 1100 cc	A. de Victor / J. Hasley	Salmson

16 LE MANS WINNING COLOURS

3000 - 5000cc Bentley Motors Ltd. *1928*

 Woolf **Barnato** Bernard **Rubin**

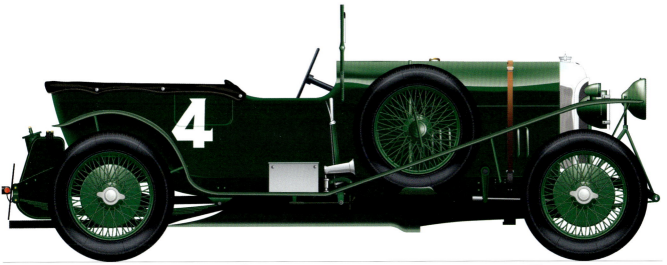

 Bentley 4½ Litre Bentley 4.4L S4 4392cc Dunlop

 06 - 16 - 17

 17 262 km

 2669.272 km

 Laps 155 *AvS* 111.219 km/h

 Henry Birkin, Bentley
8'07" 127.604 km/h

Other class winners	Drivers	Car
4th Biennial Cup - Index of Performance (Rudge Whitworth Cup)		
1500 - 2000 cc	G Casse / A Rousseau	Salmson
1100 - 1500 cc	R Benoist / C Dauvergne	Itala
750 - 1100 cc	C M Harvey / H W Purdy	Alvis
	M Doré / J Truenet	BNC

1923-1929 17

1929 Bentley Motors Ltd. 5001 - 8000cc

 Woolf *Barnato* Henry *Birkin*

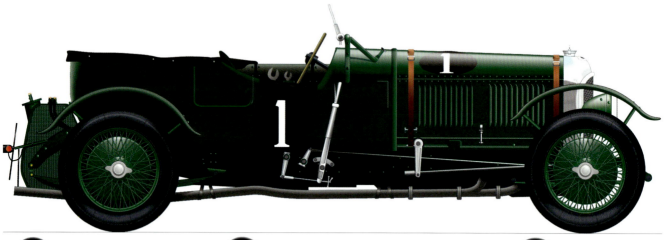

Bentley Six Speed Bentley 6.6L S6 6597cc Dunlop

06 - 15-16

16 340 km

2843.830 km
Laps 174 AvS 118.492 km/h

Henry Birkin, Bentley Speed 6
7'21" 133.551 km/h

Other class winners	Drivers	Car
5th Biennial Cup - Index of Performance (Rudge-Whitworth Trophy)		
3001 - 5000 cc	W. Barnato / H.R.S. Birkin	Bentley
	J. Dunfee / G. Kidston	Bentley
1101 - 1500 cc	K.S. Peacock / S.H. Newsome	Lea-Francis
751 - 1100 cc	L. Balart / L. Debeugny	Tracta

1930–1939

For the first time, in 1930, the ACO decided to admit private competitors. Bentley took advantage of this and officially entered three Speed Six cars; of note was the robust 4.5L belonging to Miss Dorothy Paget's team. The race started with problems for several cars whose engines suffered from the poor quality of the fuel supplied by the organisation. The 4.5L Bentleys all suffered, but not as much as the Stutz, which ended up catching fire. Another notable fact of the race is that the Bentleys were plagued with a number of tyre delaminations with their Dunlops but, despite this, they dominated the race, finishing first and second.

1930 also saw the first female competitors: French women Marguerite Mareuse and Odette Siko in a Bugatti T40 that took seventh place. The race was also broadcast for the first time via radio.

1931 saw the first victory for an Italian car at Le Mans: the Alfa Romeo 8C 2300. It was also the first car with a compressor and an 8-cylinder in-line engine to win at Le Mans. At the finish it was the hard driving of Earl Howe and Henry Birkin that gave them a comfortable seven-lap victory, and they were only the second crew to win all three prizes: outright distance, Index and the Biennial Cup.

Another change to the circuit occurred in 1932 when the distance was reduced once again, this time to 13.492km. Alfa Romeo repeated its victory of the previous year with the same car, this time with Raymond Sommer and Luigi Chinetti behind the wheel, Sommer driving for approximately twenty-one hours; it was also the first win for Englebert Tyres. There was drama for Jean Trévoux when he drove his Bentley too quickly on the first bend, spinning and rolling. He was thrown clear but suffered a broken wrist and two significant dents in his tin crash helmet, which undoubtedly saved his life.

1932 was also the last time that two-time winner Sir Henry 'Tim' Birkin would be at Le Mans (as a child, he gained the nickname 'Tim' after the character Tiger Tim from a children's book popular at the time). In May the next year, he burnt his arm on his exhaust pipe at the Tripoli Grand Prix. The wound turned septic and he died of septicaemia a week after the 1933 Le Mans race; he was 36.

In 1933, race organisers added new signage and yellow lines on the bends of the track. For the third consecutive year, Alfa Romeo won the race, this time occupying the top three places. It was also the second win for Sommer, this time driving with Tazio Nuvolari. On the Sunday morning the lead Alfa Romeo, driven by Franco Cortese, somersaulted off the road

just after Indianapolis, courtesy of a collapsed wheel bearing. Cortese managed to limp back to the pits; however, the chassis was too misaligned to continue. With hopes of a win dashed, co-driver Louis Chiron was furious, Cortese disconsolate. On the last lap, the lead changed three times, with Nuvolari beating Chinetti by just 400m.

Alfa Romeo went on to win again in 1934, outperforming Bentley, this time with Luigi Chinetti and Philippe Étancelin in the driving seat. The race day was very hot, with high temperatures melting some of the new tar-seal, so marshals spread woodchips onto the track to try to alleviate the problem. Apart from a few spins on the slippery surface, there were no serious accidents. This year was also the first time automatic refuelling pumps in the pits were used.

Two-time winner Sommer led the start of the race, but after only ninety minutes he stopped on the circuit with smoke pouring from his engine; the next five hours saw the Alfas of Chinetti and Howe dice for the lead. However, the lights failed on Howe's Alfa soon after dark, costing him two hours in the pits getting the problem fixed. Chinetti took the lead, but developed a leak in the fuel tank. The solution? The same one Sommer had used the previous year – plugging the gap with chewing gum.

The 1935 race saw the participation of ten women, but it was the victory for an English car painted red that created a stir, as there was an agreement between the teams to use colours according to the country, and the official colour for England was dark green (British Racing Green). The car in question was the Lagonda, driven by John Hindmarsh and Luis Fontés. The Lagonda looked certain to win when Fontés pitted off-schedule at 3 p.m. The car had not had its oil topped up on the previous pit stop and, with a two-lap lead, had dangerously low oil pressure. The rules stipulated it was not allowed to be replenished outside the standard pit windows, so with less than an hour to go, Fontés gingerly completed another lap. With the car running worse, the pit crew urged him to carry on, albeit very cautiously, and he limped to the finish line, winning by half a lap.

There was no race in 1936 due to strikes in France, particularly in the automotive sector. There was a record number of eleven entries though, and it was hoped the race would run on 11/12 August, but due to a lack of manpower this never happened.

The first victory for Bugatti and its drivers, Jean-Pierre Wimille and Robert Benoist, came in 1937. Tragically, the occasion was marred by a fatal accident in which six cars crashed at the Maison Blanche section, killing drivers Pat Fairfield and René Kippeurt.

In 1938 there was an unexpected win for a Delahaye 135S, which had suffered many gearbox problems throughout the race and finished with only one gear; the winning drivers were Eugène Chaboud and Jean Trémoulet. This was also the first time a vehicle with a V12 engine had entered the race – a Delahaye 145.

1939 saw the transition from stopwatches being used to time the race to electric timing, as well as a new prize of 1,000 francs being given to the leading car every hour. This race brought a second victory for Bugatti, with Jean-Pierre Wimille and Pierre Veyron behind the wheel.

5001 - 8000cc Bentley Motors Ltd. 1930

 Woolf **Barnato** Glen **Kidston**

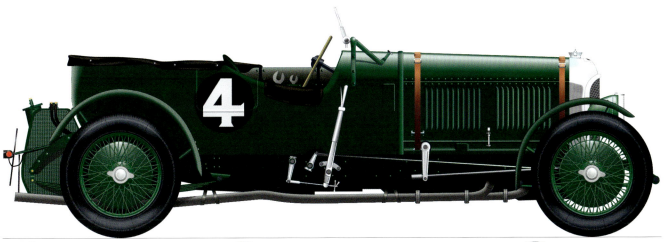

 Bentley Six Speed Bentley 6.6L S6 6597cc Dunlop

 06 - 21-22

 16 340 km

 2930.663 km

 Laps 179 *AvS* 122.111 km/h

 Sir Henry Birkin, Bentley
6'48" 144.362 km/h

Other class winners	Drivers	Car
Index of Performance 6th Biennial Cup (Rudge-Whitworth Cup)	B. Lewis / H.S. Eaton	Talbot
2001 - 3000 cc	W. Barnato / G. Kidston	Bentley
1501 - 2000 cc	B. Lewis / H.S. Eaton	Talbot
1101 - 1500 cc	Lord Howe / L.C. Callingham	Alfa Romeo
751 - 1100 cc	K.S. Peacock / S.H. Newsome	Lea-Francis
	J.A. Gregoire / F. Vallon	Tracta

1931 Earl Howe — 2001 - 3000cc

 Henry Birkin Earl Howe

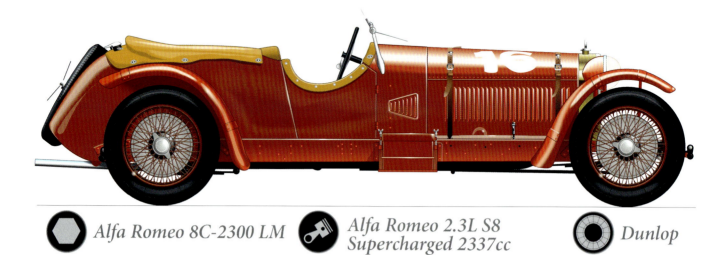

Alfa Romeo 8C-2300 LM Alfa Romeo 2.3L S8 Supercharged 2337cc Dunlop

 06 - 13-14

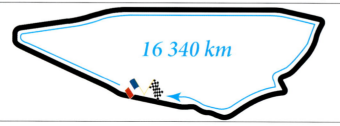 16 340 km

 3017.654 km

 Laps 184 AvS 125.735 km/h

 Boris Ivanowski, Mercedes Benz SSK 7'03" 139.234 km/h

Other class winners	Drivers	Car
7th Biennial Cup - Index of Performance (Rudge Whitworth Cup)	Lord Howe / H.R.S. Birkin	Alfa Romeo
5001 - 8000 cc	B. Ivanowski / H. Stoffel	Mercedes-Benz
1101 - 1500 cc	A.C. Bertelli / C.M. Harvey	Aston Martin
751 - 1100 cc	J.E. Vernet / F. Vallon	Caban

22 LE MANS WINNING COLOURS

2001 - 3000cc — Raymond Sommer 1932

 Luigi *Chinetti* Raymond *Sommer*

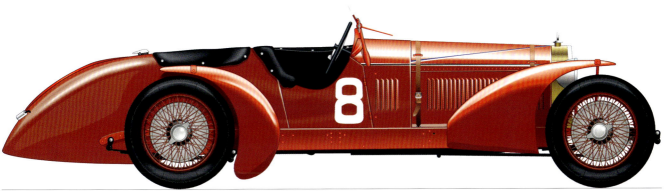

 Alfa Romeo 8C-2300 MM Alfa Romeo 2.3L S8 Supercharged 2337cc Englebert

 06 - 18-19

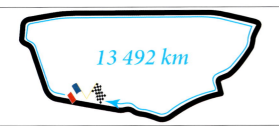 13 492 km

 2954.038 km

 Laps 218 AvS 123.084 km/h

 Ferdinando Minoia, Alfa Romeo C8
5'41" 142.437 km/h

Other class winners	Drivers	Car
Index of Performance 8th Biennial Coupe de AC de l'Ouest (Rudge-Whitworth Cup ?)	R. Sommer / L. Chinetti	Alfa Romeo
	A.C. Bertelli / L.P. Driscoll	Aston Martin
1501 - 2000 cc	Mme Siko / J. Sabipa	Alfa Romeo
1101 - 1500 cc	S.H. Newsome / H. Widengren	Aston Martin
751 - 1100 cc	C.A Martin / A. Bodoignet	Amilcar

1933 Raymond Sommer — 2001 - 3000cc

 Tazio **Nuvolari** *Raymond* **Sommer**

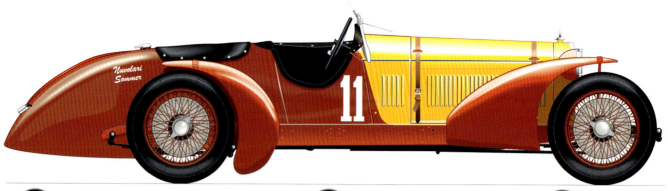

 Alfa Romeo 8C-2300 MM-LM Alfa Romeo 2.3L S8 Supercharged 2337cc Pirelli

 06-17-18

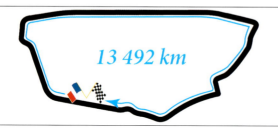 13 492 km

 3144.038 km
Laps 233 *AvS* 131.001 km/h

 Raymond Sommer, Alfa Romeo C8
5'31.4" 146.386 km/h

Other class winners	Drivers	Car
9th Biennial Cup	R. Sommer / T. Nuvolari	Alfa Romeo
Index of Performance	A.W.K. van der Becke / K.S. Peacock	Riley
1501 - 2000 cc	A. Rousseau / F. Paco	Alfa Romeo
1101 - 1500 cc	L.P. Driscoll / S.C. Penn-Hughes	Aston Martin
751 - 1100 cc	A.W.K. van der Becke / K.S. Peacock	Riley
< 750 cc	J.L. Ford / M.H. Baumer	MG

| 2001 - 3000cc | Luigi Chinetti/Philippe Etancelin | 1934 |

 Luigi Chinetti Philippe Etancelin

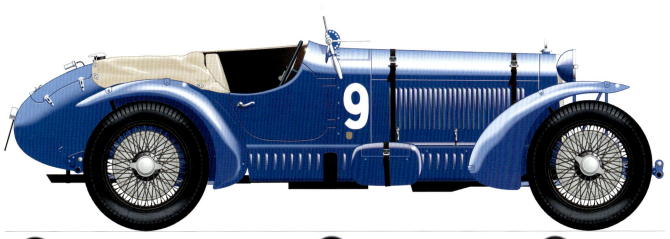

 Alfa Romeo 8C-2300 MM-LM Alfa Romeo 2.3L S8 Supercharged 2337cc Englebert

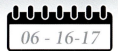 06 - 16-17

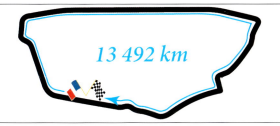 13 492 km

 2886.938 km

Laps 213 AvS 120.289 km/h

 P Philippe Etancelin, Alfa Romeo 8C
5'41" 142.437 km/h

Other class winners	Drivers	Car
10th Biennial Cup - Index of Performance (Rudge-Whitworth Cup)		
1101 - 1500 cc	A.W.K. van der Becke / K.S. Peacock	Riley
	J. Sebilleau / G. Delaroche	Riley
751 - 1100 cc	C.E.C. Martin / R. Eccles	MG

1935 Fox & Nichol — 3001 - 5000cc

 Luis *Fontés* Johnny *Hindmarsh*

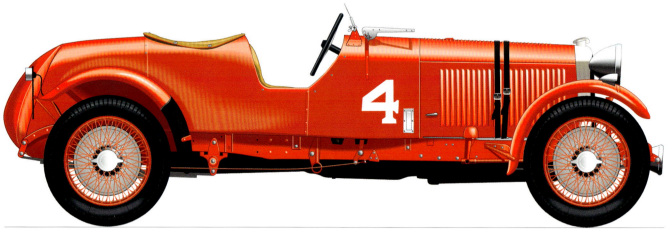

 Lagonda M45R Rapide Meadows 4.5L Dunlop

 06 - 15-16

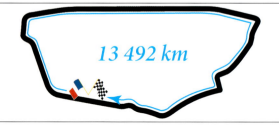 13 492 km

 3006.797 km

 222 125.283 km/h

 Earl Howe, Alfa Romeo 8C
5'47.9" 139.612 km/h

Other class winners	Drivers	Car
11th Biennial Cup - Index of Performance (Rudge-Whitworth Cup)	C.E.C. Martin / C. Brackenbury	Aston Martin
2001 - 3000 cc	"Heldé" (P.L. Dreyfus) / H. Stoffel	Alfa Romeo
1501 - 2000 cc	G. Don / J. Desvignes	Alfa Romeo
1101 - 1500 cc	C.E.C. Martin / C. Brackenbury	Aston Martin
751 - 1100 cc	P. Maillard-Brune / C. Druck	MG
< 750 cc	J. Barbour / J. Carr	Austin Seven

3001 - 5000cc	Roger Labric 1937

 Robert Benoist Jean-Pierre Wimille

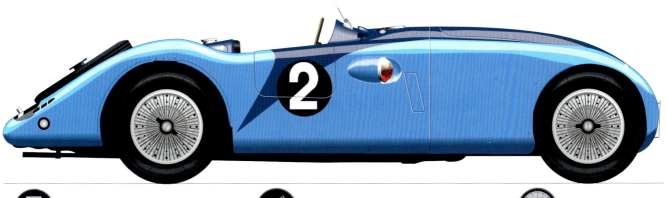

 Bugatti Type 57G Tank Bugatti 3.3L 2473cc Dunlop

 06 - 19-20

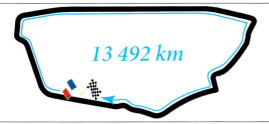 13 492 km

 3287.938 km

 Laps 244 AvS 136.997 km/h

 P Jean-Pierre Wimille, Bugatti 57G
5'13" 155.179 km/h

Other class winners	Drivers	Car
12th Biennial Cup (Rudge-Whitworth Cup)	M H Morris-Goodall / R P Hitchens	Aston Martin
Index of Performance	J P Wimille / R Benoist	Bugatti
2001 - 3000 cc	J de Valence / L Gérard	Delage
1501 - 2000 cc	Graf Orssich / R Sauerwein	Adler
1101 - 1500 cc	J M Skeffington / R C Murton-Neale	Aston Martin
751 - 1100 cc	J E Vernet / Mme Largeot	Simca
< 750	J Viale / A Alin	Simca

1938 — Eugéne Chaboud et Jean Trémoulet — 3001 - 5000cc

 Eugéne Chaboud *Jean* Trémoulet

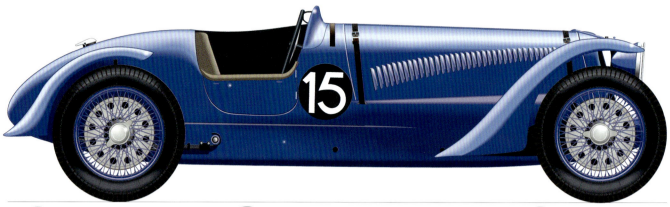

 Delahaye 135S Delahaye 3.6L 3558cc Dunlop

 06 - 18-19

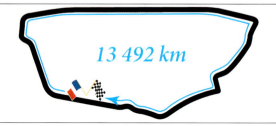 13 492 km

 3180.940 km

 235 132.539 km/h

 Raymond Sommer, Alfa Romeo 8C
5'13.8" 154.783 km/h

Other class winners	Drivers	Car
13th Biennial Cup (Rudge-Whitworth Cup)	Graf Orssich / R. Sauerwein	Adler
Index of Performance - 1st Annual Cup of ACO	M. Aimé / C. Plantivaux	Simca
1500 - 2000 cc	C. de Cortanze / M. Contet	Peugeot - Darl'Mat
1100 - 1500 cc	O. Löhr / P. von Guilleaume	Adler
750 - 1100 cc	A. Debille / G. Lapchin	Simca
< 750 cc	M. Aimé / C. Plantivaux	Simca

| 3001 - 5000cc | Jean-Pierre Wimille | 1939 |

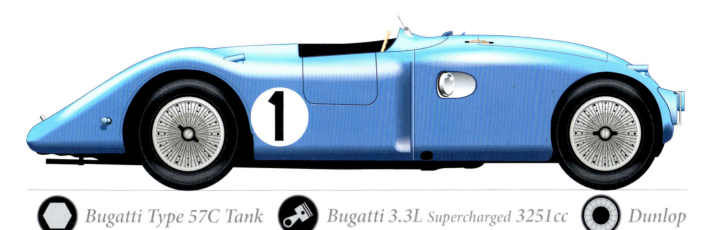

Bugatti Type 57C Tank — Bugatti 3.3L Supercharged 3251cc — Dunlop

 13 492 km

 3354.760 km

Laps 248 AvS 139.781 km/h

 Robert Mazaud, Delahaye 135 S
5'12.1" 155.627 km/h

Other class winners	Drivers	Car
14th Biennial Cup (Rudge-Whitworth Cup)	A. Gordini / J. Scaron	Simca Huit
Index of Performance - 2nd Annual Cup	A. Gordini / J. Scaron	Simca Huit
2001 - 3000 cc	L. Gérard / G. Monneret	Delage 3 L
1501 - 2000 cc	von Schaumberg-Lippe / F Wencher	BMW 328
1101 - 1500 cc	P. Clark / M. Chambers	HRG
751 - 1100 cc	A. Gordini / J. Scaron	Simca Huit
501 - 750 cc	Ad. Alin / Al. Alin	Simca Cinq

1949

The 1940 24 Hours of Le Mans had been suspended due to the outbreak of the Second World War, throughout which time the circuit was used as an airstrip by both the Allies and the Germans. During this bleak period, four Le Mans winners died: 1937 French winner Robert Benoist, who became a member of the French Resistance but was captured by the Germans and transferred to Buchenwald concentration camp, where he died in September 1944; 1928, '29 and '30 British winner Woolf Barnato, who died in 1948 during surgery; 1935 British winner Luis Fontés, who died in combat while serving with the RAF; and 1938 French winner Jean Trémoulet, who died in a motorcycle accident when he was working for the French Resistance.

After a ten-year break, the race resumed in 1949 with a renovated circuit and watched on by the President of the French Republic Vincent Auriol. This was Ferrari's first entry into Le Mans with two Type 166mm cars – one went on to win and the other failed to finish. The Type 166mm sported a V12 engine, the first car to win with a 12-cylinder engine of 1995cc. Its driver, Luigi Chinetti, drove for twenty-three hours, as Peter Mitchell-Thompson (Lord Seledon) overdid the cognac and could not drive. In 1949, the Ferrari 166 was the only car ever to win all three of the major road-racing events in Europe: Targa Florio, with drivers Clemente Biondetti and Igor Troubetzkoy; Mille Miglia, with drivers Biondetti and Giuseppe Navone; and, of course, Le Mans. Regulations for this year's Le Mans race were based on those of 1939, but with admission of prototypes. Simultaneous refills (water, oil and fuel) with an interval of twenty-five laps were permitted. Meanwhile, use of a mixed fuel (gasoline, benzol, ethanol) was responsible in part for some mechanical problems. Delettrez debuted its diesel engine, driven by owners Jacques and Jean Delettrez, retiring after only 123 laps due to lack of fuel.

3001 - 5000cc	Lord Selsdon 1949

 Luigi Chinetti Peter Mitchell-Thompson (Lord Selsdon)

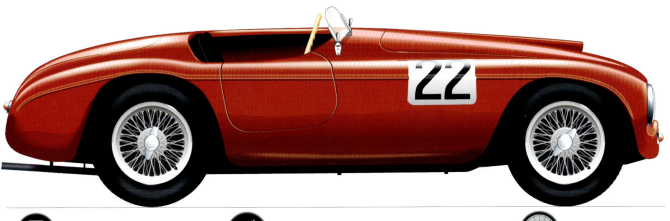

Ferrari 166MM Ferrari 2.0L V12 1995cc Englebert

06 - 25 - 26

 13 492 km

3178.299 km
Laps 235 AvS 132.420 km/h

André Simon, Delahhaye 175 S
5'12.5" 155.427 km/h

Other class winners	Drivers	Car
Index of Performance - 3rd Annual Cup	Luigi Chinetti / Lord Selsdon	Ferrari 166 MM
15th Biennial Cup		
(Rudge-Whitworth Cup)	Luigi Chinetti / Lord Selsdon	Ferrari 166 MM
3001 - 5000cc	Robert Brunet / Georges Grignard	Delahaye 135 S
2001 - 3000cc	Henri Louveau / Juan Jover	Delage D.6
1101 - 1500cc	Jack Fairman / Eric Thompson	HRG
751 - 1100cc	Jean de Montremy / Eugene Dussous	Monopole - Simca
500 - 750cc	Frantisek Sutnar / Otto Krattner	Aero Minor

1949 31

1950–1959

1950 saw the second participation of cars with diesel engines – a Delettraz that retired with engine problems and a MAP that retired after losing water. Jaguar's debut with three XK-120S-type cars resulted in twelfth and fifteenth positions for them, with the third retiring. The race was won by father-and-son duo Louis Rosier and Jean-Louis Rosier. For many years it was reported that Louis, the father, had driven for almost twenty-four hours straight, as his son, Jean-Louis, had allegedly only completed two laps! But this legend belongs to the 'folklore' of Le Mans: according to a statement by Jean-Louis himself, the two drove the car in the same way, but due to the similarity of the names, the announcer of the race became confused, always announcing the name de Louis as the pilot in action. It was the first and only time that they had won the race. The car was nothing more than a Formula 1 model equipped with headlights, mudguards and a spare tyre; the cockpit was also enlarged in order to be able to take a second person. The race saw a record number of entrants – sixty cars, which was the same number as in 1951, '53 and '55 – and radio communication was used for the first time between the two Cadillacs and the pits.

1951 saw Jaguar's first victory at Le Mans with the tubular chassis XK-120C, with Peter Walker and Peter Whitehead at the wheel. Along with the Jaguar debut came a respected name, a certain Stirling Moss. Porsche made its debut in international competitions, using the 356/4 model with an aluminium body, finishing in twentieth place and winning the category up to 1100cc. However, the race was marred by a tragic incident: at 4:31 p.m., Jacques Larivière crashed his Ferrari 212 in Tertre Rouge, which resulted in him being decapitated by an iron cable.

In 1952, lone driver Pierre Levegh, driving a Talbot Lago T26, pulled four laps ahead of the second-place driver. With only an hour and ten minutes remaining before the end of the race, the crankshaft failed, handing victory to the Mercedes 300SL, driven by Hermann Lang and Fritz Riess. This was the first victory for a German car driven by German drivers. The Mercedes, equipped with German (Continental) tyres, was the first win for a fully enclosed car. Mercedes also tested an aerodynamic brake on Karl Kling's car, located at the rear of the roof. This was designed to reduce the top speed but would not be used in the race.

1953 saw Jaguar's second victory at Le Mans with the XK-120C (also known as the Type C), with Tony Rolt and Duncan Hamilton at the wheel. Disc brakes were used for the first time – a system that was used in aircraft and developed by the aeronautical firm Lockheed. The first use of a device called a kinemometer, the predecessor of current radars, was used to

measure the speed on the fastest sector of the track, which was more than 5km in length. The winning team was the first to exceed 4,000km or, more precisely, 4,088.064km.

In 1954, the Jaguar D Type made its debut, managing second place. Driving a Ferrari, victory fell to José Froilán González and Maurice Trintignant. Despite a heavy downpour and ignition problems during the race, the Ferrari, using Formula 1 brakes, still managed to win by one lap. The track width was increased to 8m on the Mulsanne–Arnage section and the Indianapolis curve.

1955 saw the first victory for the Jaguar D Type, driven by Ivor Bueb and Mike Hawthorn, but this was overshadowed by the biggest accident ever to occur on a racing track (see page 40). The Mercedes 300SLR was the 'sport version' of the cars used in Formula 1, with an 8-cylinder in-line injection engine, using aerodynamic brakes driven by two hydraulic shafts fed by a pump activated by manual control. Alfred Neubauer invited Paul Frére to drive one of the Mercedes SLRs, but Frére had already signed with Aston Martin to drive a DB 3S, so Pierre Levegh took the seat. The use of disc brakes was widespread, with seventeen vehicles using them.

The works carried out on the circuit after the 1955 accident cost in the region of 300 million francs, including the installation of telephone lines between the boxes and the signalling station. New pits layout on the grandstand straight was also part of the update. The radius of the Dunlop curve was increased and a new track layer was laid between Maison Blanche and Tertre Rouge. The grandstands were separated from the track by a wide ditch and a deceleration zone. Other changes that occurred after the accident were that no driver would be able to drive more than fourteen hours or drive more than seventy-two consecutive laps.

In 1956, Jaguar obtained their fourth win with drivers Ron Flockhart and Ninian Sanderson.

In 1957, Jaguar entered a record five cars and finished among the top six – 1st, 2nd, 3rd, 4th and 6th – the winners being Ron Flockhart and Ivor Bueb. In the interest of the public and factory teams, there was no longer any limit on engine displacement and fuel consumption.

1958 saw Ferrari win with Phil Hill and Olivier Gendebien. Brothers Pedro and Ricardo Rodríguez were registered for the race, but Ricardo had his application refused because he was only 16 years old.

In 1959, a first win for Aston Martin, with drivers Carroll Shelby and Roy Salvadori, was also the first win for Avon Tyres. Ricardo Rodríguez was now old enough to take part and, at 17 years and 26 days old, was the youngest driver ever to participate in the race.

1950 *Louis Rosier* — 3001 - 5000cc

 Jean-Louis *Rosier* Louis *Rosier*

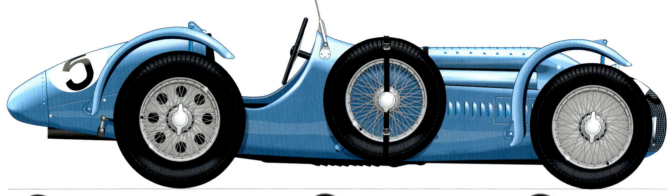

Talbot Lago Grand Sport T26 Talbot 4.5L S6 4483cc Dunlop

 06 - 24-25

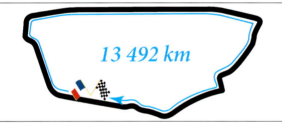 13 492 km

 → 3465.120 km

Laps 256 AvS 144.380 km/h

 Louis Rosier, Talbot Lago T26 GS
4'53.5" 165.490 km/h

Other class winners	Drivers	Car
Index of Performance - 4th Annual Cup (tie)	George Abecassis / Lance Macklin	Aston Martin DB.2
	Jean de Montremy / Jean Hémard	Monopole - Panhard
16th Biennial Cup (Rudge-Whitworth Cup)	Jean de Montremy / Jean Hémard	Monopole - Panhard
5001 - 8000cc	Sidney Allard / Tom Cole	Allard - Cadillac
2001 - 3000cc	George Abecassis / Lance Macklin	Aston Martin DB.2
1501 - 2000cc	Donald Mathieson / Richard Stoop	Frazer-Nash
1101 - 1500cc	Tommy Wisdom / Tommy Wise	Jowett Jupiter
751 - 1100cc	Jean Sandt / Hervé Coatalen	Renault 4 CV
750cc	Maurice Gatsonides / Henk Hoogeveen	Aero Minor

| 3001 - 5000cc | Peter Walker 1951 |

 Peter Walker Peter Whitehead

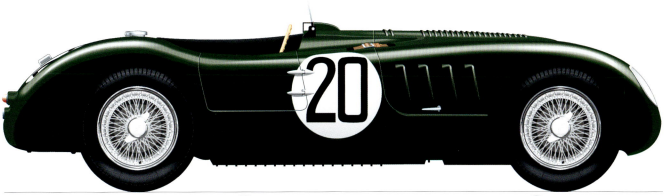

 Jaguar XK-120C Jaguar 3.4L S6 3441cc Dunlop

06 - 23-24

13 492 km

3611.193 km
Laps 267 AvS 150.466 km/h

Stirling Moss, Jaguar XK 120C
4'46.8" 169.356 km/h

Other class winners	Drivers	Car
Index of Performance - 5th Annual Cup	Jean de Montremy / Jean Hémard	Monopole - Panhard
17th Biennial Cup	Jean de Montremy / Jean Hémard	Monopole - Panhard
5001 - 8000cc	John Fitch / Phil Walters	Cunningham C2-R
2001 - 3000cc	Lance Macklin / Eric Thompson	Aston Martin DB 2
1501 - 2000cc	Count Giovanni Lurani / Giovanni Bracco	Lancia Aurelia GT
1101 - 1500cc	Marcel Becquart / Gordon Wilkins	Jowett Jupiter
751 - 1100cc	Auguste Veuillet / Edmond Mouche	Porsche 356
501 - 750cc	Francois Landon / André Briat	Renault 4 CV

1950-1959 35

1952 Daimler-Benz A.G. — 2001 - 3000cc

Herrmann **Lang**
Fritz **Riess**

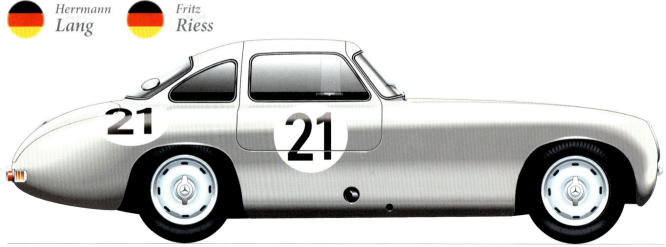

Mercedes-Benz 300 SL W194 | Mercedes-Benz 3.0L S6 2996cc | Continental

06 - 14-15

13 492 km

3733.800 km
Laps 277 — AvS 155.575 km/h

Alberto Ascari, Ferrari 250 S
4'40.5" 173.159 km/h

Other class winners	Drivers	Car
Index of Performance - 6th Annual Cup	Jean Hémard / Eugene Dussous	Monopole - Panhard
18th Biennial Cup	Jean Hémard / Eugene Dussous	Monopole - Panhard
5001 - 8000cc	Briggs Cunningham / Bill Spear	Cunningham - Chrysler
3001 - 5000cc	Leslie Johnson / Tommy Wisdom	Nash-Healey
1501 - 2000cc	Luigi Valenzano / "Ippocambo"	Lancia Aurelia
1101 - 1500cc	Marcel Becquart / Gordon Wilkins	Jowett Jupiter
751 - 1100cc	Auguste Veuillet / Edmond Mouche	Porsche 356
501 - 750cc	Jean Hémard / Eugene Dussous	Monopole - Panhard

3001 - 5000cc Jaguar Cars Ltd. 1953

 Tony **Rolt** *Duncan* **Hamilton**

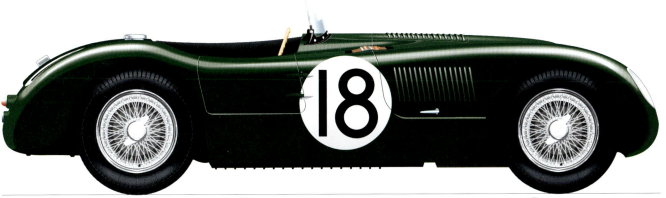

Jaguar C Type Jaguar 3.4L S6 3441cc Dunlop

06 - 13-14

13 492 km

4088.064 km

Laps 304 AvS 170.336 km/h

Alberto Ascari, Ferrari 340 MM
4'27.4" 181.642 km/h

Other class winners	Drivers	Car
Index of Performance		
7th Annual Cup	Pierre Chancel / Robert Chancel	Panhard
19th Biennial Cup	Pierre Chancel / Robert Chancel	Panhard
5001 - 8000cc	Phil Walters / John Fitch	Cunningham - Chrysler
2001 - 3000cc	Maurice Trintignant / Harry Schell	Gordini
1501 - 2000cc	Ken Wharton / Laurence Mitchell	Frazer-Nash
1101 - 1500cc	Rickard von Frankenberg / Paul Frère	Porsche 356
751 - 1100	Mario Damonte / "Helde" (Pierre-Louis Dreyfus)	OSCA
501 - 750	René Bonnet / André Moynet	D.B. - Panhard

1950-1959 37

1954 Scuderia Ferrari 3001 - 5000cc

 Jose Froilan **Gonzalez** Maurice **Trintignant**

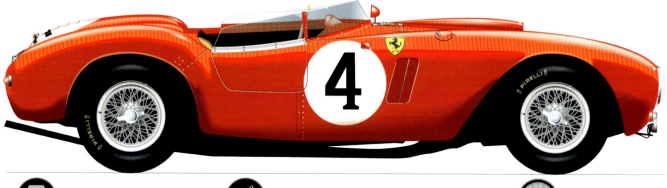

Ferrari 375 Plus Ferrari 5.0L V12 4954cc Pirelli

 06 - 12-13

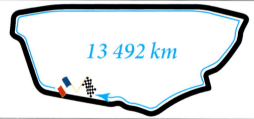 13 492 km

 4061.150 km
 Laps 302 AvS 169.215 km/h

 Jose-Froilan Gonzales, Ferrari 375 PLUS
4'16.8" 189.139 km/h

Other class winners	Drivers	Car
Index of Performance - 8th Annual Cup	René Bonnet / Élie Bayol	D.B. - Panhard
20th Biennial Cup	René Bonnet / Élie Bayol	D.B. - Panhard
5001 - 8000cc	Bill Spear / Sherwood Johnston	Cunningham - Chrysler
2001 - 3000cc	André de Guelfi / Jacques Pollet	Gordini T30 S (T15 S ?)
1501 - 2000cc	Peter Wilson / Jim Mayers	Bristol 450
1101 - 1500cc	Johnny Claes / Pierre Stasse	Porsche 550
751 - 1100cc	Zora Arcus-Duntov - Gonzaque Olivier	Porsche 356
501 - 750	René Bonnet / Elie Bayol	D. B. - Panhard

38 LE MANS WINNING COLOURS

3001 - 5000cc Jaguar Cars Ltd. 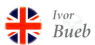 1955

 Mike Hawthorn Ivor Bueb

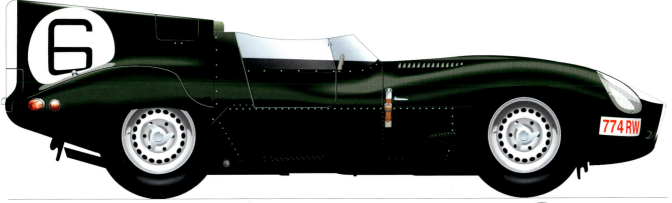

Jaguar D Type **Jaguar 3.4L S6 3442cc** **Dunlop**

06 - 11-12

13 492 km

4135.380 km
Laps 307 AvS 172.308 km/h

Mike Hawthorn, Jaguar D
4'06.6" 196.963 km/h

Other class winners	Drivers	Car
Index of Performance	Rickard von Frankenberg / Helmut Polensky	Porsche 550
21st Biennial cup	Rickard von Frankenberg / Helmut Polensky	Porsche 550
2001 - 3000cc	Peter Collins / Paul Frére	Aston Martin DB3S
1501 - 2000cc	Peter Wilson / Jim Mayers	Bristol 450 C
1101 - 1500cc	Richard von Frankenberg / Helmut Polensky	Porsche 550
751 - 1100cc	Zora Arcus-Duntov / Auguste Veuillet	Porsche 356
501 - 750cc	Louis Cornet / Robert Mougin	D.B. Panhard

1950-1959 39

The 1955 Le Mans race would go down in motorsport history as the biggest accident ever to occur in a motor race.

It was eighteen hours and twenty-eight minutes in when Pierre Levegh's Mercedes 300 SLR and Lance Macklin's Austin Healey 100S collided. There were two key factors in this accident: there was no deceleration lane for cars coming into the pits; and, just before the main straight, there was a very slight right-hand kink on the track. It was at this point that Mike Hawthorn started braking so he could stop at his pit. Macklin, following close behind, swerved left to avoid Hawthorn's slowing Jaguar, running into the path of Levegh's Mercedes, which was travelling at over 200km/h. Levegh, with no time to react, was launched over the rear of Macklin's Healey and on a trajectory towards the crowded grandstand. Levegh's car impacted the earth embankment and, slamming into a concrete spectator underpass to the pits, hurtled the major car components over 100m into the crowd. The bonnet lid acted as a guillotine, cutting down all those in its path. At 2 a.m., following factory orders, the entire team of Mercedes, who had been leading the race with Juan Manuel Fangio, withdrew. At the end of the year, Mercedes abandoned motorsport altogether, only returning in the 1990s.

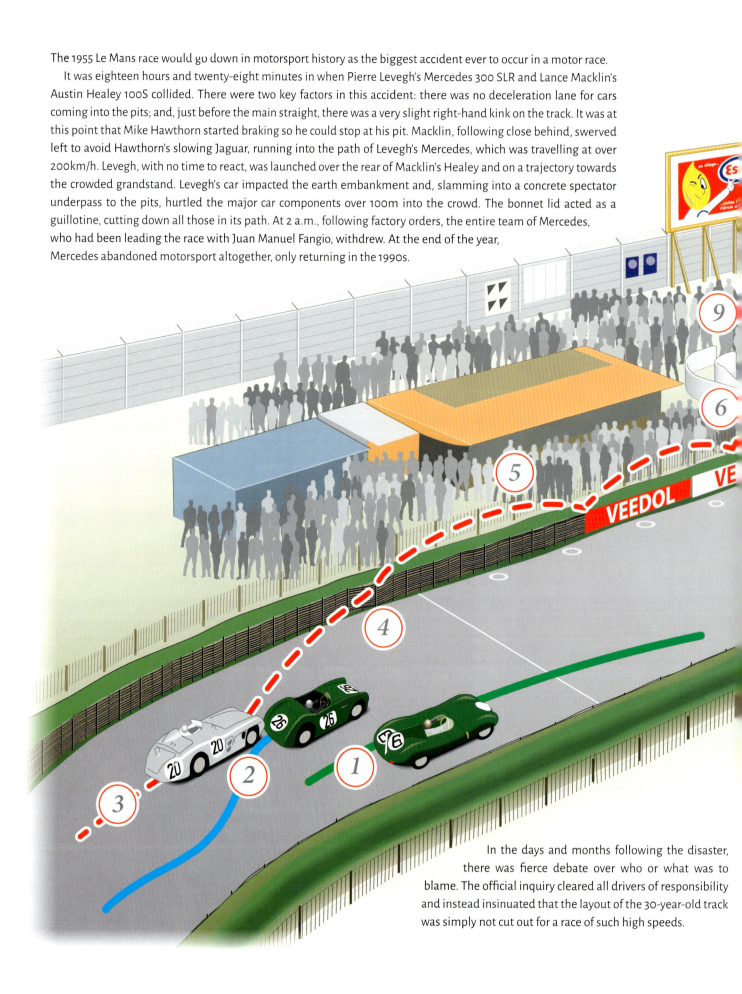

In the days and months following the disaster, there was fierce debate over who or what was to blame. The official inquiry cleared all drivers of responsibility and instead insinuated that the layout of the 30-year-old track was simply not cut out for a race of such high speeds.

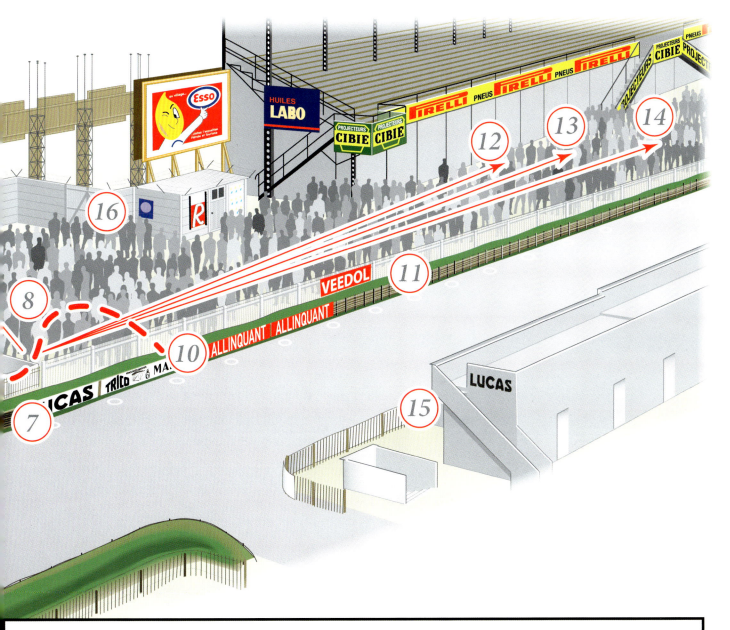

1. Mike Hawthorn (6) slows in front of Lance Macklin (26) to enter his pit.
2. Macklin swerves left to avoid Hawthorn and into the path of Pierre Levegh's 200 km/h Mercedes (20).
3. Before Levegh can react his car is launched over the rear of Macklin's Austin Healey.
4. Being airborne Levegh's car clears the banking along the edge of the circuit.
5. The first traces of paint and mirror pieces.
6. Location of first 14 victims.
7. The Mercedes strikes the concrete wall of the pedestrian underpass scattering the car's components.
8. The drive shaft lands in this area.
9. Path of bonnet.
10. Final position of Levegh's burning Mercedes.
11. Levegh's body comes to rest 75 metres from the underpass.
12. Trajectory of the engine.
13. Trajectory of the front axel.
14. Trajectory of the exhaust manifold.
15. Pits.
16. This is the area where our witness was standing. (see page 126)

1956 Ecurie Ecosse 3001 - 5000cc

Ron *Flockhart* Ninian *Sanderson*

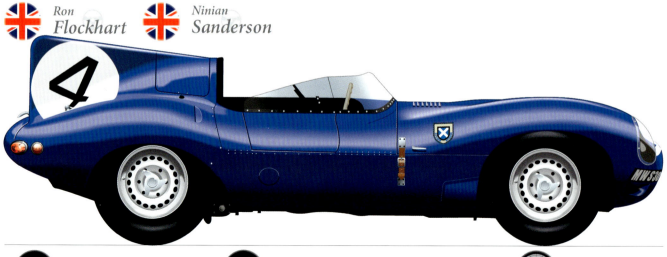

Jaguar D Type | Jaguar 3.4L S6 3442cc | Dunlop

06 - 28-29

13 461 km | 4034.929 km
Laps 300 | AvS 168.122 km/h

Mike Hawthorn, Jaguar D
4'20.0" 186.383 km/h

Other class winners	Drivers	Car
Index of Performance	Gerard Laureau / Paul Armagnac	D.B. - Panhard
22nd Biennial Cup	Gerard Laureau / Paul Armagnac	D.B. - Panhard
2001 - 3000cc	Stirling Moss / Peter Collins	Aston Martin DB 3 S
1101 - 1500cc	Graf Wolfgang von Trips / Richard von Frankenberg	Porsche 550 RS
751 - 1100cc	Reg Bicknell / Peter Jopp	Lotus XI - Climax
501 - 750cc	Gerard Laureau / Paul Armagnac	D.B. Panhard

42 LE MANS WINNING COLOURS

3001 - 5000cc — Ecurie Ecosse 1957

Ron *Flockhart* Ivor *Bueb*

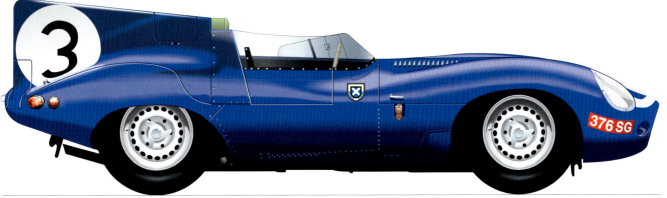

Jaguar D Type *Jaguar 3.8L S6 3781cc* *Dunlop*

06 - 22-23

13 461 km

4397.108 km
Laps 327 AvS 183.217 km/h

Mike Hawthorn, Ferrari 335 S
3'58.7" 203.015 km/h

Other class winners	Drivers	Car
Index of Performance	Cliff Allison / Keith Hall	Lotus XI - Climax
23rd Biennial Cup	No finishers	
2001 - 3000cc	Jean-Paul Colas / Jean Kerguen	Aston Martin DB 3 S
1501 - 2000cc	Lucien Bianchi / Georges Harris	Ferrari 500 TRC
1101 - 1500cc	Ed Hugus / Baron Carel Godin de Beaufort	Porsche 550 RS
751 - 1100cc	Herbert Mackay-Fraser / Jay Chamberlain	Lotus XI - Climax
501 - 750cc	Cliff Allison / Keith Hall	Lotus XI - Climax

1958 Scuderia Ferrari 2001 - 3000cc

 Olivier Gendebien *Phil* Hill

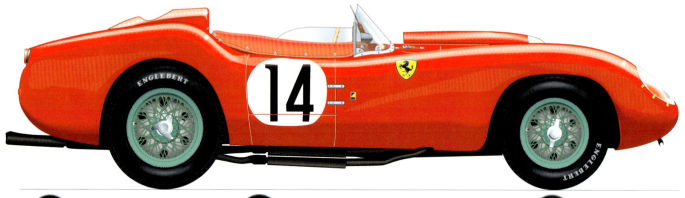

● Ferrari 250 TR58 ● Ferrari 3.0L V12 2953cc ● Englebert

 06 - 21-22

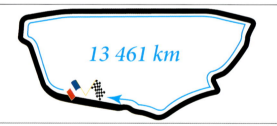 13 461 km

 → 4101.926 km
Laps 305 *AvS* 170.914 km/h

 Mike Hawthorn, Ferrari 250 TR
4'08.0" 195.402 km/h

Other class winners	Drivers	Car
Index of Performance	Alejandro de Tomaso / Colin Davis	Osca S750
24th Biennial Cup	No finishers	
1501 - 2000cc	Jean Behra / Hans Herrmann	Porsche 718 RSK
1101 - 1500cc	Edgar Barth / Paul Frére	Porsche 718 RSK
501 - 750cc	Alejandro de Tomaso / Colin Davis	Osca S750

Sport-Prot. 2001 - 3000cc — David Brown Racing Dept. 1959

 Carroll Shelby Roy Salvadori

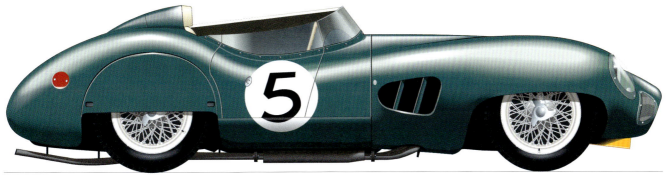

 Aston Martin DBR1/300 Aston Martin 3.0L S6 2993cc Avon

 06 - 20 - 21

 13 461 km

 4347.900 km

Laps 323 AvS 181.163 km/h

 Jean Behra, Ferrari 250 TR/59 4'00.9" 201.161 km/h

Other class winners	Drivers	Car
Index of Performance	Louis Cornet / René Cotton	D.B. Panhard
25th Biennial Cup	Louis Cornet / René Cotton	D.B. Panhard
Index of Thermal Efficiency	Bernard Consten / Paul Armagnac	D.B. Panhard
GT 2001 - 3000cc	"Jean Beurlys" / "Eldé"	Ferrari 250 GT
GT 1501 - 2000cc	Ted Whiteaway / Jack Turner	A.C. Ace - Bristol
GT 1101 - 1500cc	Peter Lumsden / Peter Riley	Lotus Elite
GT 501 - 750cc	Louis Cornet / René Cotton	D.B. Panhard

1950–1959 45

1960–1969

Ferrari took the honours in 1960, with drivers Paul Frère and Olivier Gendebien, and again in 1961, this time with Phil Hill and Olivier Gendebien. It was the second victory for Hill, who was also the Formula 1 World Champion, also with Ferrari. The pace by the Rodríguez brothers (19 and 21 years old) at the wheel of a Ferrari was remarkable – Ricardo would set the fastest lap of the race – but they were forced to retire in the twenty-third hour.

1962 would be the last victory for a front-engine car at Le Mans – Phil Hill and Olivier Gendebien's Ferrari 330 LM.

As of 1963, the position on the grid was given by the times obtained in practice, which until now had been given by the engine capacity. Ferrari completely dominated this year's race, with the victory belonging to the 250 P driven by Lorenzo Bandini and Ludovico Scarfiotti; this was the first victory for a rear-engine car.

In practice for the 1964 race, Lucky Casner tragically died following an accident on the Mulsanne Straight, with victory going to the Ferrari 275 P of Jean Guichet and Nino Vaccarella. This race also marked the official debut of the Ford GT40, one of which took the fastest lap of the race.

Ferrari grabbed yet another victory in 1965 with the 250/275 LM, in the hands of Masten Gregory and Jochen Rindt. However, in this year's victory, Ed Hugus, who was an alternate driver for Ferrari, was called to replace Gregory during the night because Gregory had a problem with his glasses fogging. Rindt was not sleeping at the circuit and could not be found, so Hugus was called to take the wheel wearing Rindt's helmet. As Hugus had taken the place as reserve driver, Rindt could not take the wheel again. This detail was kept hidden until Hugus died in 2006.

The 1964 Fords had a lot of problems with the 4-speed non-synchronised Colotti gearbox; in addition, the power was increased by 50hp, so Ford switched to the 5-speed synchronised ZF, thus solving the gearbox problem. This race also saw the first victory for Goodyear Tyres.

Out of the twelve Ford GT 40s entered for the 1966 race, nine were to retire and the remaining three, all Mk II models, obtained first, second and third places, pole position and the fastest lap of the race. Henry Ford II (Henry Ford's grandson) had proved to Enzo Ferrari

that his cars could defeat the Ferraris. However, it was the most disputed finish at Le Mans. Ford officials wanted the cars that were holding the first three positions to cross the finishing line in formation. The leading car of Ken Miles and Dennis Hulme (No. 1), which was a few hundred metres in front on the same lap, was instructed from the pits to slow and let the second- and third-placed cars catch up, crossing the finish line with car No. 1 at the front, followed by cars No. 2 and No. 5. Then came the realisation that the distance that separated car No. 1 from car No. 2 on arrival was 20m shorter than the distance that separated them at the starting grid. So, logically, and by virtue of a Le Mans regulation, after twenty-four hours of competition the Chris Amon and Bruce McLaren team (No. 2) had covered 20m more than Hulme and Miles, thus Amon and McLaren were declared the winners.

In 1967, Ford entered a new version of the GT40, the Mk IV, built in Michigan by KAR KRAFT, it was also a first all-American victory: American car, American engine, American drivers and American tyres. The winner was also the first competitor to reach the historic mark of 5,000km, or more precisely, 5,232.900km. This was also another first with the use of slick tyres in the race for the Renault Alpine A210 and CD SP 66. Champagne was used for the first time at the podium ceremony and Dan Gurney, excited by the victory, shook the champagne bottle so much that it sprayed over everyone, a tradition that still takes place today.

The 1968 race, initially scheduled for 15/16 June, took place on 28/29 September. This change had to do with the strikes that affected all of France. At the finish, it was a comfortable five-lap victory for the GT40 of Pedro Rodríguez and Lucien Bianchi.

Sadly, in March 1969, whilst practising for the forthcoming race, Bianchi suffered a fatal accident wherein he lost control of the Alfa Romeo T33 SE on the Mulsanne Straight, which hit a post and caught fire. Bianchi was killed instantly.

The 1969 race was scheduled to start earlier, at 2 p.m., due to the French presidential election. It would be the last entry for the Ford GT40, of which three of the five entries reached the finish in first, third and sixth places, Jacky Ickx being teamed with Jackie Oliver. Porsche debuted their 917, which would be considered one of the best competition cars ever built. Of the three cars that entered the race, two retired due to mechanical problems and the third crashed at the beginning of the race, killing driver John Woolfe (see page 6).

1960 Scuderia Ferrari — Sportscars, CSI Class 12, 2501-3000cc

 Paul *Frére*

 Olivier *Gendebien*

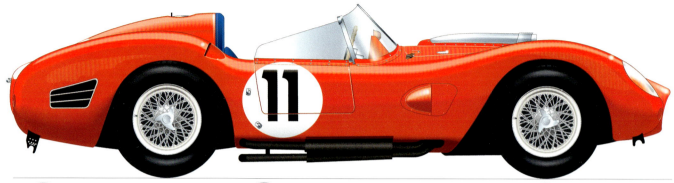

 Ferrari 250 TR59/60 Ferrari 3.0L V12 2958cc Dunlop

 06 - 25-26

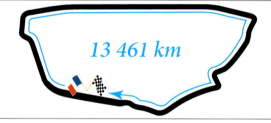 13 461 km

 4217.527 km

Laps 314 AvS 170.914 km/h

 Masten Gregory, Maserati TIPO 61
4'04.0" 198.605 km/h

Other class winners	Drivers	Car
Index of Performance	Gérard Laureau / Paul Armagnac	DB - Panhard
Index of Termal Efficiency	John Wagstaff / Tony Marsh	Lotus Elite
26th Biennial Cup	Gérard Laureau / Paul Armagnac	DB - Panhard
Sportscars, CSI Class 5, 701-850cc	Gérard Laureau / Paul Armagnac	DB - Panhard
Sportscars, CSI Class 6, 851-1000cc	John Dalton / John Colgate	Austin Healey
Sportscars, CSI Class 9, 1301-1600cc	Herbert Linge / Heini Walter	Porsche Carrera
Sportscars, CSI Class 10, 1601-2000cc	Ted Lund / Colin Escott	MGA
GT Cars, CSI Class 8, 1151-1300cc	Claude Laurent / Roger Masson	Lotus Elite
GT Cars, CSI Class 12, 2501-3000cc	Fernand Tavano / Pierre Loustel	Ferrari 250 GT
GT Cars, CSI Class 14, 4001-5000cc	John Fitch / Bob Grossman	Chevrolet Corvette

Sportscars, 2001-3000cc — Scuderia Ferrari 1961

 Olivier Gendebien Phil Hill

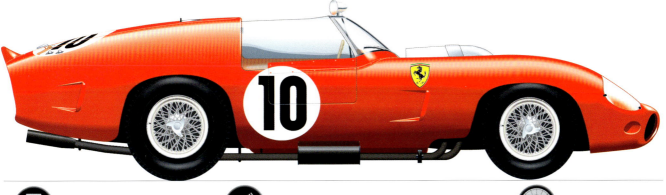

 Ferrari 250 TRI/61 Ferrari 3.0L V12 2961cc Dunlop

 06 - 10 - 11

 13 461 km

 4476.580 km

 Laps 333 AvS 186.527 km/h

 Ricardo Rodriguez, Ferrari TRI/61
3'59.9" 201.202 km/h

Other class winners	Drivers	Car
Index of Performance	Gerard Laureau / Robert Bouharde	D.B. Panhard
Index of Thermal Efficiency	Peter Harper / Peter Procter	Sunbeam Alpine
Sports Cars 1601 - 2000cc	Masten Gregory / Bob Holbert	Porsche RS
Sports Cars 701 - 850cc	Denis Hulme / Angus Hyslop	Fiat Abarth
GT Cars 2001 - 3000cc	Pierre Noblet / Jean Guichet	Ferrari 250 GT
GT Cars 1601 - 2000cc	Jean-Claude Magne / Georges Alexandrovitch	AC Ace
GT Cars 1301 - 1600cc	Herbert Linge / Ben Pon	Porsche 695 GS
GT Cars 1001 - 1300cc	Bill Allen / Trevor Taylor	Lotus Elite

1962 *Scuderia Ferrari* — *Experimental 3001 - 4000cc*

 Olivier *Gendebien* Phil *Hill*

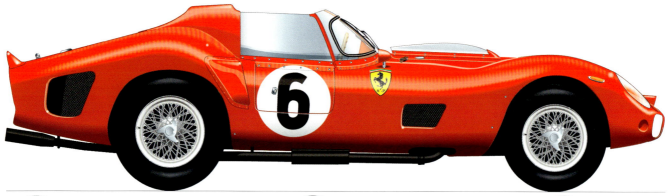

 Ferrari 330 TRI/LM Spyder Ferrari 4.0L V12 3967cc Dunlop

 06 - 23-24

 13 461 km

 4451.255 km
 331 185.255 km/h

 Phil Hill, Ferrari 330 LM
3'57.7" 204.202 km/h

Other class winners	Drivers	Car
Index of Performance	André Guilhaudin / Alain Bertaut	C.D. Panhard
Index of Thermal Efficiency	David Hobbs / Frank Gardner	Lotus Elite
Experimental 2501 - 3000cc	Bob Grossman / Fireball Roberts	Ferrari 250 GTO
Experimental 1151 - 1300cc	Claude Dubois / George Harris	Abarth Simca
Experimental 851 - 1000cc	Bernard Consten / José Rosinski	René Bonnet
Experimental 701 - 850cc	André Guilhaudin / Alain Bertaut	C.D. Panhard
GT 3001 - 4000cc	Briggs Cunningham / Roy Salvadori	Jaguar E
GT 2501 - 3000cc	Jean Guichet / Pierre Noblet	Ferrari 250 GTO
GT 1601 - 2000cc	Chris J. Lawrence / Richard Shepherd-Barron	Morgan Plus-Four
GT 1301 - 1600cc	Edgar Barth / Hans Herrmann	Porsche 1600 GS
GT 1151 - 1300cc	David Hobbs / Frank Gardner	Lotus Elite

Prototype 2001 - 3000 cc SpA Ferrari SEFAC 1963

Lorenzo **Bandini** *Ludovico* **Scarfiotti**

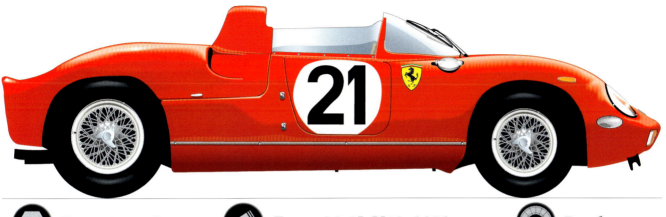

Ferrari 250 P Ferrari 3.0L V12 2953cc Dunlop

06 - 15-16

 13 461 km

4561.710 km
Laps 339 AvS 190.071 k m/h

Pedro Rodriguez, Ferrari
3'50.9" 209.873 km/h

John Surtees, Ferrari 250 P
3'53.3" 207.714 km/h

Other class winners	Drivers	Car
Index of Performance	Ludovico Scarfiotti / Lorenzo Bandini	Ferrari 250 P
Index of Thermal Efficiency	Jean-Pierre Beltoise / Claude Bobrowski	René Bonnet LM6
Special A.C.O. Award	Graham Hill / Richie Ginther	Rover - BRM
Prototype 1601 - 2000 cc	Edgar Barth / Herbert Linge	Porsche 718
Prototype 1001 - 1150 cc	Jean-Pierre Beltoise / Claude Bobrowski	René Bonnet LM6
GT 4001 - 5000 cc	Peter Bolton / Ninian Sanderson	A.C. Cobra
GT 3001 - 4000 cc	Jack Sears / Mike Salmon	Ferrari 330 LMB
GT 2001 - 3000 cc	"Beurlys" / Gerard Langlois van Ophem	Ferrari GTO
GT 1601 - 2000 cc	Paddy Hopkirk / Alan Hutcheson	MG B
GT 1151 - 1300 cc	John Wagstaff / Pat Ferguson	Lotus Elite

1960-1969 51

1964 SpA Ferrari SEFAC — *Prototype 3001 - 4000 cc*

 Jean *Guichet* / Nino *Vaccarella*

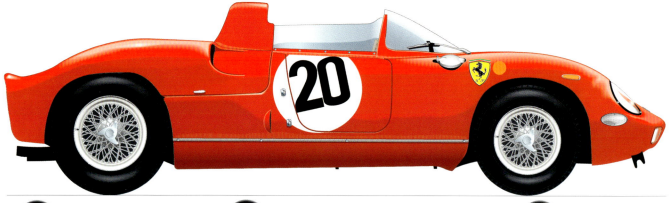

 Ferrari 275 P Ferrari 3.3L V12 2953cc Dunlop

 06 - 20-21

 13 461 km

 4695.310 km

 Laps 349 AvS 195.638 km/h

 John Surtees, Ferrari 330P
3'42.00" 218.286 km/h

 Phil Hill, Ford GT40
3'49.20" 211.429 km/h

Other class winners	Drivers	Car
Index of Performance	Jean Guichet / Nino Vaccarella	Ferrari 275 P
Index of Thermal Efficiency	Henry Morrogh / Roger Delageneste	Alpine Renault
Prototype 5001 - unlimited	Edgar Berney / Pierre Noblet	Iso Rivolta
Prototype 1001 - 1150cc	Henry Morrogh / Roger Delageneste	Alpine Renault
GT 4001 - 5000cc	Dan Gurney / Bob Bondurant	Cobra Ford
GT 2001 - 3000cc	Lucien Bianchi / "Beurlys"	Ferrari GTO
GT 1601 - 2000cc	Robert Buchet / Guy Ligier	Porsche 904
GT 1301 - 1600cc	Roberto Bussinello / Bruno Deserti	Alfa Romeo TZ
GT 1151 - 1300cc	Clive Hunt / John Wagstaff	Lotus Elite
GT 1001 - 1150cc	Philippe Farjon / Serge Lelong	René Bonnet

Prototype 3001 - 4000 cc — North American Racing Team 1965

 Masten Gregory Jochen Rindt Ed Hugus

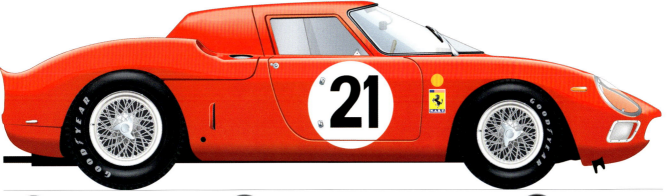

 Ferrari 250 LM Ferrari 3.3L V12 3285cc Goodyear

 06 - 19-20

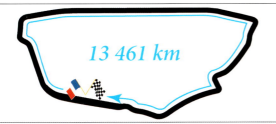 13 461 km

 4677.110 km

Laps 348 AvS 194.88 km/h

 Phil Hill, Ford MKII
3'33.00" 227.509 km/h

 Phil Hill, Ford MKII
3'37.50" 222.803 km/h

Other class winners	Drivers	Car
Index of Performance	Herbert Linge / Peter Nöcker	Porsche 904
Index of Thermal Efficiency	Gerhard Koch / Toni Fischhaber	Porsche 904 GTS
Prototype 5001 - unlimited	Regis Fraissinet / Jean de Mortemart	Iso Grifo
Prototype 4001 - 5000cc	Pedro Rodriguez / Nino Vaccarella	Ferrari 365 P2
Prototype 1601 - 2000cc	Herbert Linge / Peter Nöcker	Porsche 904
Prototype 1151 - 1300cc	Paul Hawkins / John Rhodes	Austin-Healey Sprite
GT 4001 - 5000cc	Jack Sears / Richard Thompson	AC Shelby Cobra
GT 3001 - 4000cc	Willy Mairesse / "Beurlys"	Ferrari 275 GTB
GT 1601 - 2000cc	Gerhard Koch / Toni Fischaber	Porsche 904 GTS
GT 1001 - 1151cc	Jean-Jacques Thuner / Simo Lampinen	Triumph Spitfire

1966 Shelby-American Inc. *Prototype Unlimited*

 Bruce **McLaren** Chris **Amon**

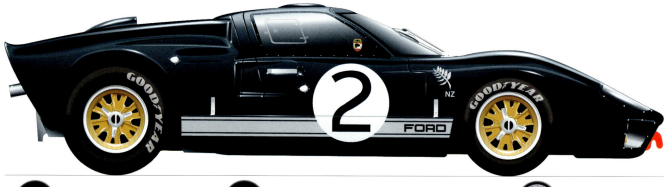

Ford GT40 Mk.ll Ford 7.0L V8 2953cc Goodyear

06 - 18 - 19

13 461 km 4843.090 km Laps 360 AvS 210.795 km/h

Dan Gurney, Ford GT40 MKll 3'30.06" 230.103 km/h
Dan Gurney, Ford GT40 MKll 3'30.06" 230.103 km/h

Other class winners	Drivers	Car
Index of Performance	Jo Siffert / Colin Davis	Porsche 906
Index of Thermal Efficiency	Jacques Cheinisse / Roger Delageneste	Alpine Renault A210
Prototype 1601 - 2000cc	Jo Siffert / Colin Davis	Porsche 906
Prototype 1151 - 1300cc	Henri Grandsire / Leo Cella	Alpine Renault A210
Sports Cars	Günther Klass / Rolf Stommelen	Porsche 906
GT 3001 - 5000cc	Piers Courage / Roy Pike	Ferrari 275 GTB
GT 1601 - 2000cc	"Franc" / Jean Kerguen	Porsche 911 S

LE MANS WINNING COLOURS

Prototype Unlimited Shelby-American Inc. *1967*

 Dan **Gurney** Anthony Joseph 'AJ' **Foyt**

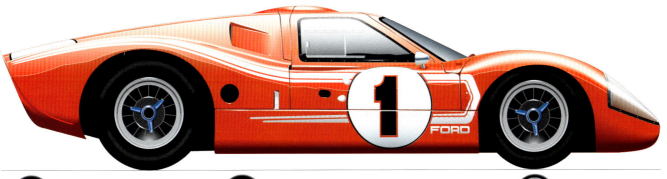

 Ford GT40 Mk.lV Ford 7.0L V8 6980cc Goodyear

 06 - 10-11

 13 461 km

 5232.900 km

Laps 388 *AvS* 218.038 km/h

 Bruce McLaren
Ford GT40 MKlV 3'24.40" 236.082 km/h

 Denis Hulme & Mario Andretti
Ford GT40 MKlV 3'23.06" 238.014 km/h

Other class winners	Drivers	Car
Index of Performance	Jo Siffert / Hans Herrmann	Porsche 907
Index of Thermal Efficiency	Dan Gurney / A.J. Foyt	Ford Mk IV
Prototypes 4001 - 5000cc	Ludovico Scarfiotti / Mike Parkes	Ferrari P4
Prototypes 1601 - 2000cc	Jo Siffert / Hans Herrmann	Porsche 907
Prototypes 1301 - 1600cc	Jean Vinatier / Mauro Bianchi	Alpine Renault
Prototypes 1151 - 1300cc	Henri Grandsire / José Rosinski	Alpine Renault
Sports Cars 1601 - 2000cc	Vic Elford / Ben Pon	Porsche 906
Sports Cars 1151 - 1300cc	Marcel Martin / Jean Mesange	Abarth 1300 GT
GT	Rico Steinemann / Dieter Spoerry	Ferrari 275 GTB

1968 — J. W. Automotive Engineering — *Sportscars*

 Pedro **Rodriguez**
 Lucien **Bianchi**

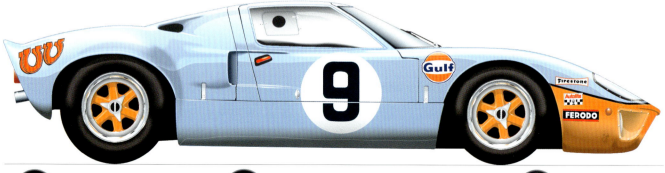

Ford GT40 Mk.l — Ford 4.9L V8 4942cc — Firestone

 09 - 28 - 29

13 469 km

4452.880 km
Laps 331 AvS 185.536 km/h

Jo Siffert, Porsche 908 3'35.4" 225.108 km/h
Rolf Stommelen, Porsche 908/8 3'38.1" 222.321 km/h

Other class winners	Drivers	Car
Index of Performance	Jean-Claude Andruet/Jean-Pierre Nicolas	Alpine Renault A210
Index of Thermal Efficiency	Jean-Luc Thérier / Bernard Tramont	Alpine Renault A210
Sport-Proto. 2501 - 3000cc	Rolf Stommelen / Jochen Neerpasch	Porsche 908
Sport-Proto. 2001 - 2500cc	Dieter Spoerry / Rico Steinemann	Porsche 907
Sport-Proto. 1601 - 2000cc	Ignazio Giunti / Nanni Galli	Alfa Romeo Tipo 33B/2
Sport-Proto. 1301 - 1600cc	Alain LeGuellec / Alain Serpaggi	Alpine Renault A210
Sport-Proto. 1001 - 1150cc	Jean-Claude Andruet/Jean-Pierre Nicolas	Alpine Renault A210
GT	Jean-Pierre Gaban/Roger Van der Schrick	Porsche 911 T

| Sportscars | J. W. Automotive Engineering | *1969* |

 Jacky **Ickx** *Jackie* **Oliver**

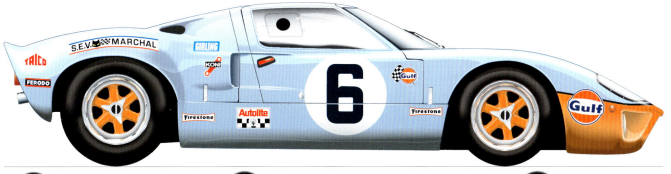

 Ford GT40 MK.l Ford 4.9L V8 4942cc Firestone

 06 - 14-15

 13 469 km

 4997.880 km

Laps 372 *AvS* 208.545 km/h

 Rolf Stommelen, Porsche 917 LH 3'22.9" 238.976 km/h

 Vic Elford, Porsche 917 LH 3'27.2" 234.017 km/h

Other class winners	Drivers	Car
Index of Thermal Efficiency	Alain Serpaggi / Christian Ethuin	Alpine Renault A210
Index of Performance	Jacky Ickx / Jackie Oliver	Ford GT 40
Sport-Prototypes 2501 - 3000cc	Hans Herrmann / Gerard Larrousse	Porsche 908
Sport-Prototypes 1601 - 2000cc	Christian Poirot / Pierre Maublanc	Porsche 910
Sport-Prototypes 1001 - 1150cc	Alain Serpaggi / Christian Ethuin	Alpine Renault A210
GT	Jean-Pierre Gaban / Yves Deprez	Porsche 911 S

1970–1979

The 1970 start was made with the cars 'on spine', but this time the driver was inside the car with the engine off, as a result of the fatal accident that happened in 1969 with John Woolfe. Two official Porsche teams took part in the race and this was also the first entry to Le Mans for a car with a rotary engine – the Chevron B16 with a 2-rotor Mazda engine that failed to finish the race. This was also to be Derek Bell's first race at Le Mans – he would go on to win it five times. He was teamed up with Ronnie Peterson in a Ferrari 512 S but retired from the race. This was the first victory for the Porsche 917, and the first for a 12-cylinder opposed engine (boxer); Hans Herrmann and Richard Attwood took the honours.

1971 saw Porsche's second victory with the 917, driven by Helmut Marko and Gijs van Lennep, breaking several records such as a timed average of 222.304km/h and a distance covered of 5,335.313km. A pit-entry deceleration zone was created, separated from the track. During qualifying, Jo Siffert was lucky to survive an accident on the way out of Maison Blanche when he crashed at 240km/h.

1972 saw the first Matra-Simca win with drivers Henri Pescarolo and Graham Hill, who had been Formula 1 World Champion in 1962 and 1968. German Hans Stuck – son of German Formula 1 driver Hans Stuck, who raced in the early 1950s – participated for the first time.

The 1973 race was famed for the duel between Ferrari and Matra, which lasted twenty-three hours, with the Matra of Henri Pescarolo and Gérard Larousse taking the chequered flag. The race was involved in some controversy due to the winning car having changed the starter motor during the race, which was prohibited by the regulations.

In 1974, the first turbo engine appeared at Le Mans through two Porsche Carrera RSRs, with Gijs van Lennep and Herbert Müller bringing one car home in second place while the other retired.

1975 was the first entry for Toyota with a Sigma MC 75 that retired with oil-pump problems. Teammates Jacky Ickx and Derek Bell brought the Mirage Ford home in first place, with the team's second car taking third.

1976 saw the first victory for a turbo engine at Le Mans, with the Porsche 936, driven by Ickx and van Lennep. The Renault Alpine A442 took pole position and obtained the fastest lap of the race, but failed to finish.

For the first time, the winning car of the 1977 race was driven by three drivers instead of the usual two. It had been a long time since there had been such a diversity of marques among the top ten, which included Porsche, Mirage, Inaltera, De Cadenet, Chevron and BMW. Newbie American driver Hurley Haywood teamed up with Ickx, and Jürgen Barth went on to win the race in a Porsche 936.

1978 saw the continuation of the duel between Porsche and Renault that started the previous year. In its third consecutive entry, the Renault Alpine A442 B took the win with drivers Didier Pironi and Jean-Pierre Jaussaud. This was the first victory for a car equipped with a V6 engine. The top speed of 367km/h was also reached by a Renault. Jean Rondeau considered creating a six-wheel car inspired by the Tyrrell P34 of Formula 1 with a Ford Cosworth DFX Turbo engine and Hewland TL200 gearbox modified by Rondeau himself. During practice, two acrylic covers were used in the cockpit of the Renault Alpines, which resulted in an additional 5km/h of maximum speed on the straights. The cover was used by Pironi and Jaussaud in the race.

As in 1969, the '79 race started at 2 p.m. due to the European Parliament election, but was disrupted by a storm that hit during the second half of the race. 54-year-old actor Paul Newman finished in an excellent second place, driving a Porsche 935 of the IMSA category, which he won with Rolf Stommelen and Dick Barbour. The winner was a Group 5 Porsche 935 (the first for a car of this class), which was a lower category and defeated the official and semi-official prototypes. Its drivers were Klaus Ludwig (a Le Mans rookie) and Don and Bill Whittington. This victory was the first for a private team (Kremer Racing) since 1965. The winning car also broke the alternator belt, and, after some time off, the car resumed its drive with a new belt. It was never established where said belt came from.

1970 Porsche KG Salzburg — *Sportscars, up to 5000cc*

 Hans Herrmann *Richard* Attwood

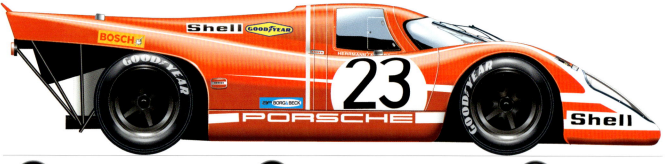

 Porsche 917 KH Coupé Porsche 4.5L F12 4494cc Goodyear

 06 - 13-14

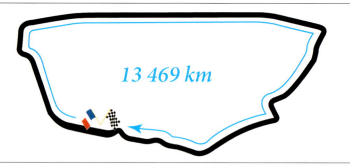

13 469 km

 4607.810 km

Laps 343 *AvS* 191.992 km/h

 Vic Elford, Porsche 917 LH
3'19.80" 242.685 km/h

 Vic Elford, Porsche 917 LH
3'21.00" 241.235 km/h

Other class winners	Drivers	Car
Index of Performance	Rudi Lins / Helmut Marko	Porsche 908
Index of Thermal Efficiency	Gerard Larrousse / Willi Kauhsen	Porsche 917 L
Sports-prototypes, up to 3000cc	Rudi Lins / Helmut Marko	Porsche 908
GT 2000 - 2500cc	Erwin Kremer / Nicholas Koob	Porsche 911 S
GT, up to 2000cc	Guy Chasseuil / Claude Ballot-Léna	Porsche 914/6

60 LE MANS WINNING COLOURS

| *Sportscars, up to 5000cc* | *Martini Racing Team* *1971* |

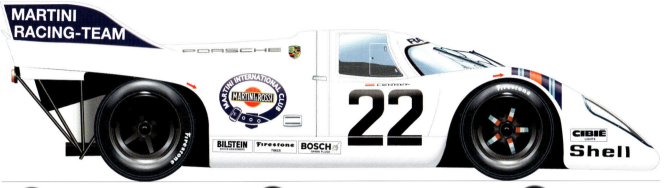

 Porsche 917 KH Coupé *Porsche 4.9L F12 4907cc* *Firestone*

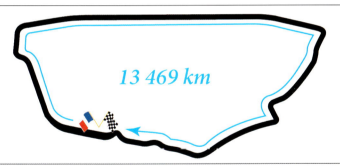

13 469 km

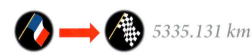 *5335.131 km*

 397 *222.304 km/h*

 Pedro Rodriguez, Porsche 917 LH
3'13.90" 250.069 km/h

 Jackie Oliver, Porsche 917 LH
3'18.4" 244.387 km/h

Other class winners	Drivers	Car
Index of Performance	Helmut Marko / Gijs van Lennep	Porsche 917 K
Index of Thermal Efficiency	Bob Grossman / Luigi Chinetti Jr	Ferrari 365 GTB/4
Sports-prototypes, up to 2000cc	Walter Brun / Peter Mattli	Porsche 907
GT up to 2500cc	Raymond Touroul / "Anselme"	Porsche 911 S

1972 — Equipe Matra-Simca Shell — Sportscars, up to 3000cc

 Henri **Pescarolo** *Graham* **Hill**

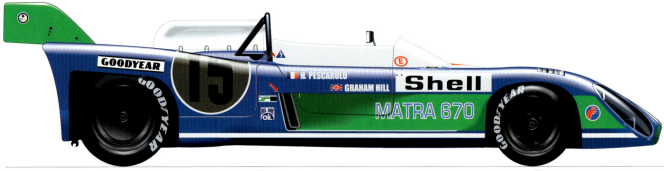

 Matra-Simca MS670 Matra 3.0L V12 2993cc Goodyear

 06 - 10 - 11

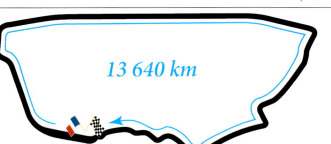 13 640 km

 4691.343 km

 Laps 344 AvS 195.472 km/h

 Francois Cevert, Matra-Simca MS 670
3'42.20" 220.990 km/h

 Gijs van Lennep, Lola T280
3'46.9" 216.413 km/h

Other class winners	Drivers	Car
Index of Thermal Efficiency	J-C. Andruet / C. Ballot-Léna	Ferrari 365 GTB
Sportscars up to 2000cc	René Ligonnet / Barrie Smith	Lola T290 - Cosworth
GTS over 5000cc	Dave Heinz / Bob Johnson	Chevrolet Corvette
GTS up to 5000cc	J-C. Andruet / C. Ballot-Léna	Ferrari 365 GTB
GTS up to 2500cc	M. Keyser / J. Barth / S. Garant	Porsche 911 S
Touring Special	Gerry Birrell / Claude Bourgoignie	Ford Capri

Sportscars, up to 3000cc — Equipe Matra-Simca Shell — 1973

Henri **Pescarolo** *Gérard* **Larrousse**

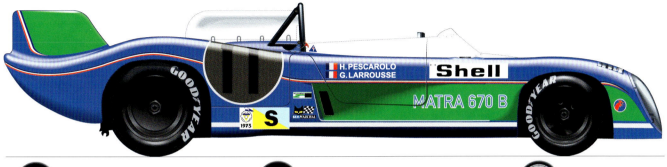

Matra-Simca MS670 B — Matra 3.0L V12 2993cc — Goodyear

06 - 9 - 10

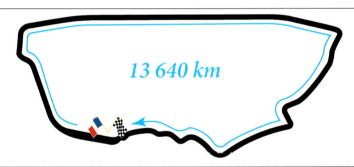 13 640 km

4853.945 km
Laps 355 AvS 202.247 km/h

Arturo Merzario, Ferrari 312 PB 3'37.5" 225.766 km/h
Francois Cevert, Matra Simca MS 670B 3'39.6" 223.607 km/h

Other class winners	Drivers	Car
Index of Thermal Efficiency	P. Keller / E. Kremer / C. Schickentanz	Porsche Carrera RSR
GTS unlimited	Henri Greder / Marie-Claude Beaumont	Chevrolet Corvette
GTS up to 5000cc	Claude Ballot-Léna / Vic Elford	Ferrari 365 GTB
Touring Special	Toine Hezemans / Dieter Quester	BMW 3.0 CSL

1970-1979 63

1974 Equipe Gitanes — Sport 2001-3000cc

 Henri *Pescarolo* Gérard *Larrousse*

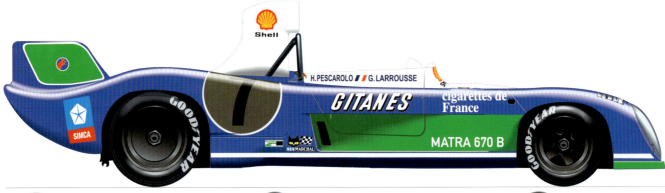

 Matra-Simca MS670 C Matra 3.0L V12 2993cc Goodyear

 06 - 15-16

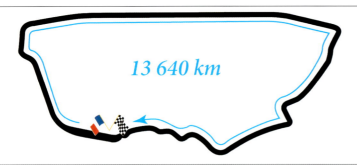 13 640 km

 4606.571 km

 Laps 338 AvS 191.940 km/h

 Henri Pescarolo, Matra-Simca MS 670 3'35.80" 227.554 km/h

 Jean-Pierre Jarier, Matra Simca MS 680 3'42.7" 220.494 km/h

Other class winners	Drivers	Car
Index of Thermal Efficiency	Cyril Grandet / Dominique 'Bardini'	Ferrari 365 GTB/4
Sport 2001 - 3000cc	Henri Pescarolo / Gerard Larrousse	Matra-Simca MS670 C
Sport - 2000cc	Y. Fontaine / C. Beckers / M. Laurent	Chevron B23 - Cosworth FVC
GTS, unlimited	Henri Greder / Marie-Claude Beaumont	Chevrolet Corvette
GTS - 5000cc	Cyril Grandet / Dominique 'Bardini'	Ferrari 365 GTB/4
Touring Special	Jean-Claude Aubriet / 'Depnic'	BMW CSL

Sports over 2000cc Gulf Research Racing Co. *1975*

 Derek Bell Jacky Ickx

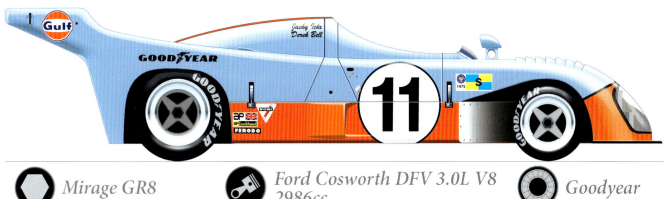

Mirage GR8 Ford Cosworth DFV 3.0L V8 2986cc Goodyear

 06 - 14-15

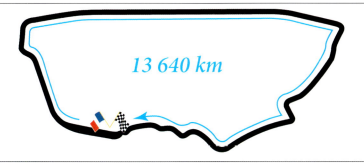 13 640 km

→ 4595.577 km

Laps 336 AvS 191.482 km/h

Jacky Ickx, Gulf Mirage GR8
3'49.90" 213.589 km/h

Chris Craft, De Cadenet Lola T 380 LM
3'53.80" 210.025 km/h

Other class winners	Drivers	Car
Sports under 2000cc	Marianne Hoepfner/Michele Mouton/Christine Dacremont	Moynet - Simca
GT Special	John Fitzpatrick / Gijs van Lennep	Porsche Carrera
GT Production	Gerhard Maurer / Christian Beez / Eugen Strähl	Porsche Carrera
GT Experimental	Bernard Beguin / Peter Zbinden / Claude Haldi	Porsche Carrera
Touring Special	Daniel Brillat / Giancarlo Gagliardi / Michel Degoumois	BMW 2002

1976 *Martini Racing Porsche System* Group 6 over 2000cc

 Jacky **Ickx** *Gijs van* **Lennep**

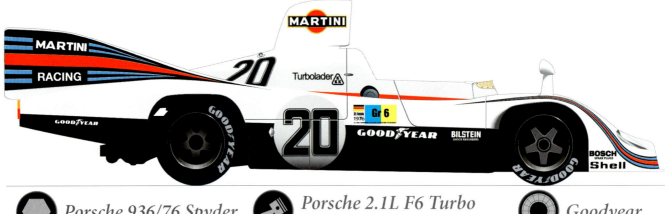

 Porsche 936/76 Spyder Porsche 2.1L F6 Turbo 2986cc Goodyear

 06 - 12-13

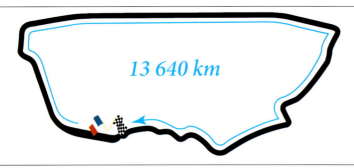 13 640 km

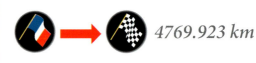 4769.923 km

 Laps 349 AvS 198.746 km/h

 Jean-Pierre Jabouille, Renault Alpine A442 3'33.10" 230.427 km/h Jean-Pierre Jabouille, Renault Alpine A442 3'43.00" 220.197 km/h

Other class winners	Drivers	Car
Group 6 under 2000cc	F. Trisconi / G. Morand / A. Chevalley	Lola T292 - Cosworth
Group 5	Rolf Stommelen / Manfred Schurti	Porsche 935
Group 4	"Segolen" / M.Ouviere / J.-Y. Gadal	Porsche Carrera
IMSA	J.-P. Laffeach / J. Rulon-Miller / T. Vaugh	Porsche Carrera
GT Prototype	Henri Pescarolo / J.-P. Beltoise	Inaltera - Cosworth DFV
Group 2	J.-L. Ravenel / J.-M. Detrin / J. Ravenel	BMW

Group 6 over 2000cc — Martini Racing Porsche System 1977

 Jacky *Ickx* Jürgen *Barth* Hurley *Haywood*

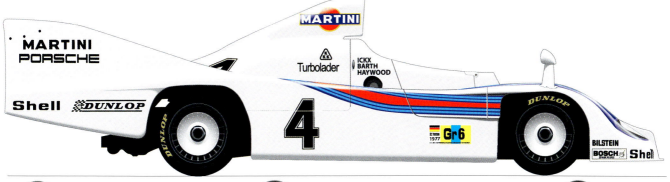

 Porsche 936/77 Spyder Porsche 2.1L F12 *Twin Turbo* 2986cc Dunlop

 06 - 11 - 12

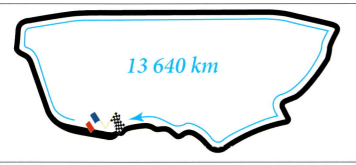 13 640 km

 4671.830 km

 Laps 342 AvS 194.651 km/h

 Jean-Pierre Jabouille, Renault Alpine A442
3'31.70" 231.951 km/h

 Jacky Ickx, Porsche 936
3'36.5" 226.808 km/h

Other class winners	Drivers	Car
Index of Thermal Efficiency	M. Pignard / J. Henry / A. Dufrene	Chevron - ROC
Group 6 under 2000cc	M. Pignard / J. Henry / A. Dufrene	Chevron - ROC1982
Group 5	C. Ballot-Léna / P. Gregg	Porsche 935
Group 4	B. Wollek / P. Gurdjian / 'Steve'	Porsche 934
IMSA	J. Xhenceval / P. Dieudonne / S. Dini	BMW CSL

1978 Alpine Renault — Group 6 over 2000cc

 Didier **Pironi** Jean-Pierre **Jaussaud**

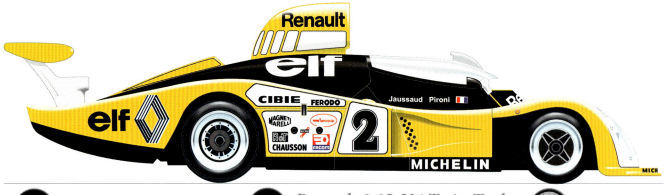

 Renault Alpine A442B Renault 2.0L V6 Twin Turbo 1997cc Michelin

 06 - 10-11

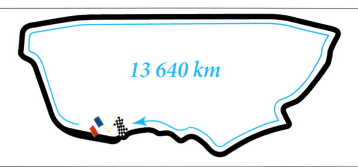 13 640 km

 5044.530 km

 Laps 369 AvS 210.188 km/h

 Jacky Ickx, Porsche 936 3'27.60" 236.531 km/h

 Jean-Pierre Jabouille, Renault Alpine A443 3'34.20" 229.244 km/h

Other class winners	Drivers	Car
Index of Thermal Efficiency	B. Wollek / J. Barth / J. Ickx	Porsche 936/78
Group 6 under 2000cc	M. Pignard / L. Rossiaud / L. Ferrier	Chevron B36 - Chrysler
Group 5	J. Busby / C. Cord / R. Knoop	Porsche 935/77A
Group 4	A.-C. Verney / X. Lapeyre / F. Servanin	Porsche Carrera
IMSA	B. Redman / D. Barbour / J. Paul	Porsche 935/77A
GT Prototype	B. Darniche / J. Rondeau / J. Haran	Rondeau M378 - Cosworth

Group 5 — Porsche Kremer Racing *1979*

 Klaus Ludwig Don Whittington Bill Whittington

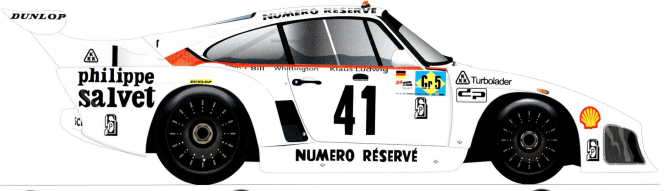

 Porsche 935 K3 Porsche 930/79 3.0L F6 2994cc Dunlop

 06 - 9-10

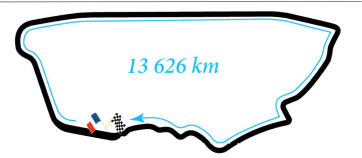 13 626 km

 4173.930 km

Laps 306 AvS 173.913 km/h

 Bob Wollek, Porsche 936
3'30.07" 233.519 km/h

 Jacky Ickx, Porsche 936
3'36.1" 227.003 km/h

Other class winners	Drivers	Car
Group 6, over 2000cc B.	Darniche / J. Ragnotti	Rondeau M379 - Cosworth
Group 6, under 2000cc	T. Charnell / R. Smith / R. Jones	Chevron B36 - Ford
Group 5	K. Ludwig / D. Whittington / B. Whittington	Porsche 935
Group 4	A. Pallavicini / H. Müller / M. Vanoli	Porsche 934
GT Prototype	J-D. Raulet / M. Mamers	WM P.79 - Peugeot
IMSA	D. Barbour / R. Stommelen / P. Newman	Porsche 935

8

1980–1989

1980 saw the first and only driver and constructor winner Jean Rondeau, who, with Jean-Pierre Jaussaud, drove a Rondeau M379 B. Pole position was not occupied by the fastest vehicle but by the average of the times obtained by the drivers of the same car, which gave pole to the Rondeau with a time of 3:47.9, even though the shortest qualifying time was Fitzpartick's 3:40.2 in a Porsche 935 K3. There were twenty-nine turbo-charged cars entered for the race. The official Porsche 924s were equipped with pneumatic jacks powered by compressed air, and Charles Pozzi's Ferrari 512BB was equipped with an on-board radio.

1981 saw the safety car being used for the first time in Le Mans history, due to several serious accidents. This was the second victory for the Ickx–Bell partnership – the pair had previously won in 1975 – this time with a Porsche 936; Ickx also took pole position. Ground effect was used for the first time on the Ardex and the Lola T600, but in the case of the Lola, this limited the straight-line speed to 319km/h.

In 1982, Porsche won in all five categories: Group C, IGTX, Group 5, Group 4 and IGT. In the general classification Porsche obtained the first three positions with the rookie 956 that, besides the victory, also got pole position; for the third time the victory went to Ickx and Bell, this being Ickx's sixth victory overall. Group 6 Lancia LC1s utilised the ground effect and, for the first time, the warm-up was used, similar to Formula 1.

In 1983, Porsche had eight cars in the top eight (in the top ten, nine were Porsche 956s). This year's race saw the biggest victory at Le Mans for the Porsche 956, with drivers Al Holbert, Hurley Haywood and Vernon Schuppan. Mazda took victory in the C Junior Group, the drivers being Yoshimi Katayama, Takashi Yorino and Yojiro Terada. For the first time, a film camera was used on board one of the cars so that spectators from all over the world could see a driver's-eye view.

In 1984, the Rothmans Porsche team boycotted the official competition due to a disagreement between Porsche and the ACO. It was a victory for Henri Pescarlolo and Klaus

Ludwig driving a Porsche 956. Jaguar returned to Le Mans with two XJR 5s, but both cars were forced to retire.

The 1985 pole position achieved by Hans Stuck in a Porsche 962 was the absolute record for the Le Mans lap to date: 3:14.8 with an average of 251.815km/h. The winning Porsche 956 of the Joest Racing team had the same chassis, the same engine and the same number (7) as used in the previous year. After fifteen races, this was to be the last time Jacky Ickx would race at Le Mans.

In 1986, Porsche won, taking the top seven positions. It was an unforgettable victory, equal to that of 1984; only the victory of 1983 was greater. It was also the first victory for the 962 model, capable of speeds of 370–390km/h, with drivers Hans Stuck, Derek Bell and Al Holbert. Jaguar returned through the Tom Walkinshaw Racing (TWR) team, as well as Mercedes-Benz through Sauber. The eighth change to the circuit took place, reducing the circuit to 13,528km, with the Mulsanne hook being redesigned due to the construction of a new roundabout.

1987 saw the ninth change to the circuit with the addition of the Dunlop chicane. The number of spectators further increased, in part due to the 35,000 English fans who came to support Jaguar, but it would be the Porsche trio of Stuck, Bell and Holbert who would win again in their Porsche 935. Jan Lammers, Johnny Dumfries and Andy Wallace gave Jaguar their first win since 1957, allowing Dunlop to celebrate its centenary with this victory. Sadly, Holbert was killed in a plane crash in Columbus, Ohio, a year later. He had won Le Mans three times, in 1983, '86 and '87.

In 1989, thirty-seven years after the 300SL's victory in 1952, Sauber Mercedes took first, second and fifth places with the C9, as well as pole position. The winners were Jochen Mass, Manuel Reuter and Stanley Dickens.

1980 *Jean Rondeau* *Group 6, over 2000cc*

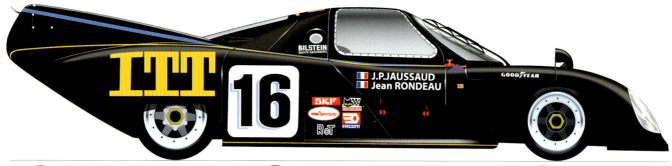

 Rondeau M379B-Ford Ford Cosworth DFV 3.0L V8 2993cc Goodyear

 06 - 14-15

13 626 km

 → 4608.020 km

Laps 338 AvS 191.899 km/h

 John Fitzpatrick, Porsche 935 K3 3'40.02" 222.177 km/h

 Jacky Ickx, Porsche 908/80 3'40.6" 222.373 km/h

Other class winners	Drivers	Car
Index of Thermal Efficiency	J. Rondeau / J-P. Jaussaud	Rondeau M 379 B
Group 6, under 2000 cc	P. Hesnault / B. Sotty / D. Laurent	Chevron - ROC B36
GT Prototype	G. Spice / P. Martin / J.M. Martin	Rondeau M 379 B
IMSA	J. Fitzpatrick / B. Redman / R. Barbour	Porsche 935 K3
Group 5	D. Schornstein / H. Grohs / G. von Tschirnhaus	Porsche 935
Group 4	T. Perrier / R. Carmillet	Porsche 911 SC

Group 6 — Porsche System *1981*

 Jacky *Ickx* Derek *Bell*

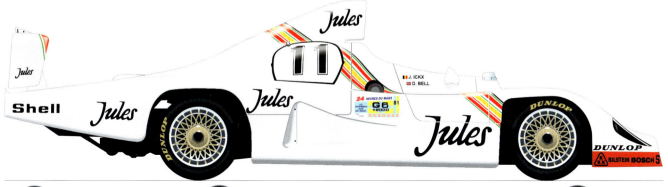

Porsche 936/81 — Porsche 935/82 2.6L F6 Turbo 2993cc — Dunlop

06 - 13 - 14

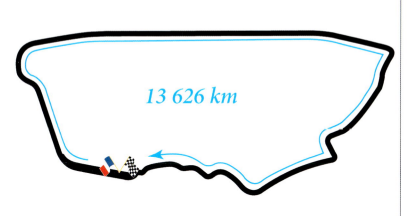 13 626 km

4825.348 km

AvS 201.056 km/h

Laps 354

Jacky Ickx, Porsche 936
3'29.44" 234.213 km/h

Hurley Haywood, Porsche 936/81
3'34.00" 229.231 km/h

Other class winners	Drivers	Car
GTP	Jacky Haran/Jean-Louis Schlesser/Philippe Streiff	Rondeau M379CL - Ford Cosworth DFV/Mader
GTO	Manfred Schurti/Andy Rouse	Porsche 924 Carrera GTR
G4	Thierry Perrier/Valentin Bertapelle/Bernard Salam	Porsche 934 Carburol

1982 Rothmans Porsche System Group C

 Jacky **Ickx** *Derek* **Bell**

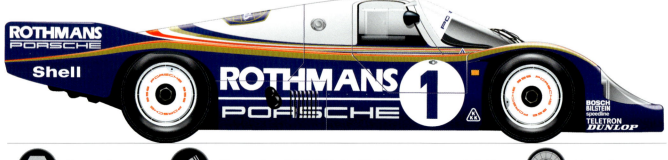

Porsche 956 Porsche 935/76 2.6L F6 *Twin Turbo* 2649cc Dunlop

06 - 19-20

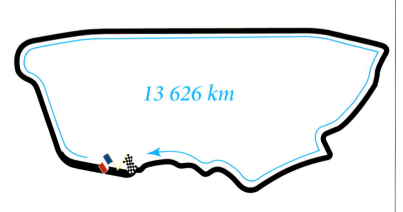

13 626 km

4899.086 km

AvS 204.128 km/h

Laps 359

Jacky Ickx, Porsche 956
3'28.40" 235.381 km/h

Jean Ragnotti, Ford Rondeau M382
3'36.90" 226.166 km/h

Other class winners	Drivers	Car
IGTX	John Fitzpatrick/David Hobbs	Porsche 935-81 'Moby Dick'
5	John Cooper/Paul Smith/Claude Bourgoignie	Porsche 935 K3
4	Richard Cleare/Tony Dron/Richard Jones	Porsche 934
IGT	Jim Busby/Doc Bundy	Porsche 924 GTR

74 LE MANS WINNING COLOURS

Group C — Rothmans Porsche 🇩🇪 1983

 Vern *Schuppan*
 Al *Holbert*
 Hurley *Haywood*

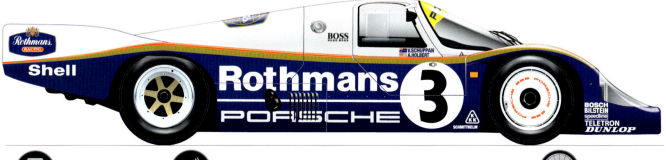

Porsche 956 — Porsche Type-935 2.6L Turbo F6 2649cc — Dunlop

06 - 18-19

5047.934 km

AvS 210.330 km/h

Laps 371

Jacky Ickx, Porsche 956
3'16.56" 249.560 km/h

Jacky Ickx, Porsche 956
3'29.7" 233.922 km/h

13 626 km

Other class winners	Drivers	Car
Group C Junior	Y. Katayama / Y. Terada / T. Yorino	Mazda 717 C
Group B	J. Cooper / P. Smith / D. Ovey	Porsche 911 Turbo

1984 *Joest Racing* *Group C1*

Henri
Pescarolo *Klaus Ludwig*

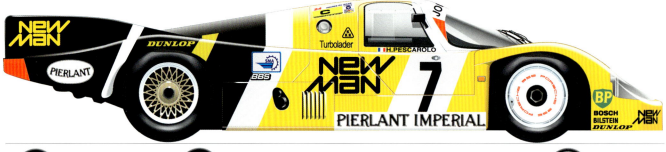

 Porsche 956B Porsche Type-935 2.6L Turbo F6 2649cc Dunlop

 06 - 16-17

 4900.276 km

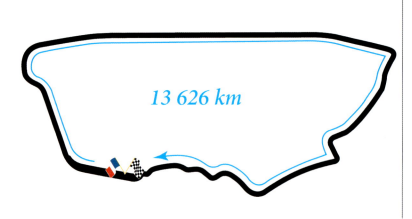
13 626 km

 204.178 km/h

 Laps 360

 Bob Wollek, Lancia Martini LC3
3'17.11" 248.864 km/h

 Alessandro Nannini, Lancia LC2 T
3'28.9" 234.818 km/h

Other class winners	Drivers	Car
C2	John O'Steen, / John Morton, / Yoshami Katayama,	Lola-Mazda
B	Philippe Dagoreau, / Jean-Francois Yvon, F / Pierre de Thoisy,	BMW M1
GTO	Raymond Touroul, / Valentin Bertapelle, / Thierry Perrier,	Porsche 911

C1 Group — Joest Racing — 1985

 Klaus Ludwig
 Paolo Barilla
 John Winter (Louis Krages)

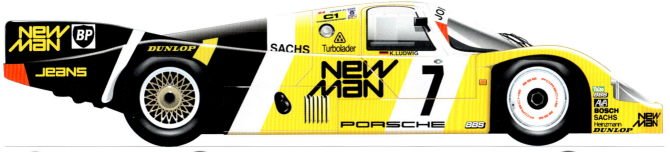

- Porsche 956B
- Porsche Type-935 2.6L Turbo F6 2649cc
- Dunlop

06 - 15-16

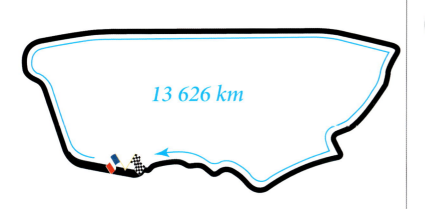 13 626 km

5088.507 km
AvS 212.021 km/h
Laps 374

 Hans-Joachim Stuck, Porsche 962 C — 3'14.80" 251.815 km/h

 Jacky Ickx, Porsche 962 C — 3'25.1" 239.169 km/h

Other class winners	Drivers	Car
C2	Ian Harrower, GB / Steve Earle, USA / John Sheldon,	GB Gebhart - Ford
GTP	Bob Tullius / Chip Robinson / Claude Ballot-Léna	Jaguar
B	No finishers	

1980-1989 77

1986 Rothmans Porsche — Group C1

 Derek Bell Al Holbert Hans-Joachim Stuck

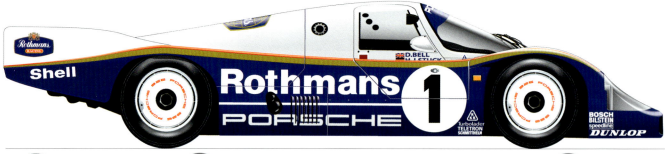

 Porsche 962C Porsche Type-935 2.6L Turbo F6 2649cc Dunlop

 05-31 - 06-01

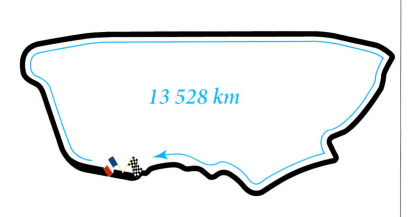

13 528 km

 4972.731 km

 AvS 207.197 km/h

 Laps 368

 Jochen Mass, Porsche 962 C
3'15.99" 248.486 km/h

 Klaus Ludwig, Porsche 956
3'23.3" 239.551 km/h

Other class winners	Drivers	Car
C2	Ian Harrower / Evan Clements / Tom Dodd-Noble	Gebhart - Ford Cosworth
GTX	René Metge / Claude Ballot-Léna	Porsche 961
GTP	Richard Cleare / Lionel Robert / Jack Newsum	March - Porsche
B (sport)	No finishers	

| Group C1 | Rothmans Porsche | 1987 |

 Derek **Bell** *Al* **Holbert** *Hans-Joachim* **Stuck**

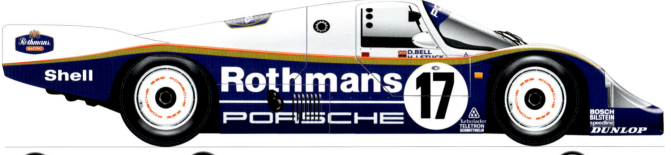

 Porsche 962C Porsche Type-935 3.0L Turbo F6 2995cc Dunlop

 06 - 13 -14

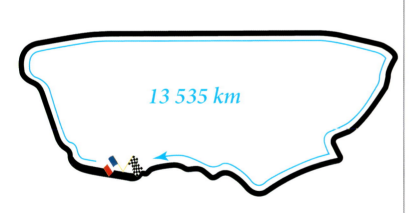 13 535 km

 4791.700 km

 AvS 199.661 km/h

 Laps 355

 Bob Wollek, Porsche 962 C
3'21.0" 242.309 km/h

 Johnny Dumfries, Sauber Mercedes C9
3'25.4" 237.224 km/h

Other class winners	Drivers	Car
C2	Gordon Spice/Fermin Velez/Philippe de Henning	Spice Pontiac Fiero SE86C-Ford Cosworth DFL
IMSA	David Kennedy/Mark Galvin/Pierre Dieudonné	Mazda 757

1988 Silk Cut Jaguar — Group C1

Jan Lammers · **Johnny Dumfries** · **Andy Wallace**

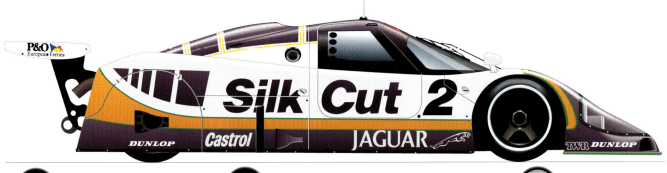

Jaguar XJR-9LM · Jaguar 7.0L V12 7000cc · Dunlop

06 - 11 - 12

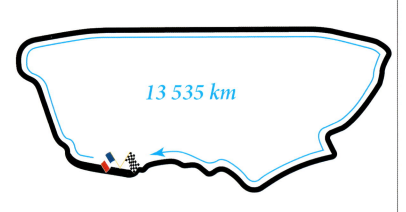

13 535 km

5332.970 km

AvS 221.765 km/h

Laps 394

Hans-Joachim Stuck, Porsche 962 C 3'15.64" 250.059 km/h

Hans-Joachim Stuck, Porsche 962 C 3'22.50" 240.622 km/h

Other class winners	Drivers	Car
C2	Ray Bellm/Gordon Spice/Pierre de Thoisy	Spice Fiero SE88C - Ford Cosworth DFL
IMSA	Yojiro Terada/David Kennedy/Pierre Dieudonné	Mazda 757

Group C1 — Team Sauber Mercedes 🇩🇪 *1989*

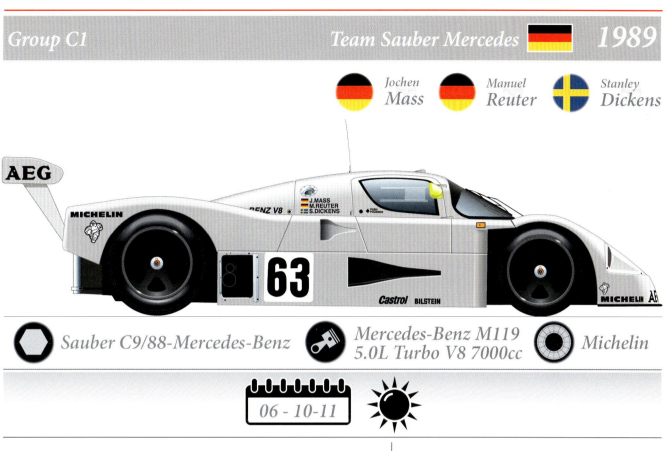

Jochen Mass 🇩🇪 · **Manuel Reuter** 🇩🇪 · **Stanley Dickens** 🇸🇪

- Sauber C9/88-Mercedes-Benz
- Mercedes-Benz M119 5.0L Turbo V8 7000cc
- Michelin

06 - 10 - 11 ☀

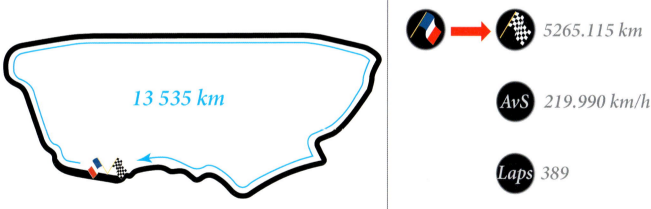

- 5265.115 km
- AvS 219.990 km/h
- Laps 389
- 13 535 km

P Jean-Louis Schlesser, Sauber Mercedes C9 — 3'15.04" 249.826 km/h
F Alain Ferté, Jaguar XJR9 LM — 3'21.27" 242,093 km/h

Other class winners	Drivers	Car
GTP	David Kennedy/Pierre Dieudonné/Chris Hodgetts	Mazda 767 B
C2	Jean-Claude Andruet/Philippe Farjon/Shunji Kasuya	Cougar C20 LM Porsche

1990–1999

The 1990 race saw Jaguar win again, this time with the XJR 12 model – an evolution of the XJR 9, which won the 1988 race – driven by John Nielsen, Price Cobb and Martin Brundle. Second place also went to Jaguar, after the second-placed Porsche retired fifteen minutes from the end due to engine problems. For this race, two chicanes had been built on the Mulsanne Straight for safety reasons. In one of the hottest races ever, thirty cars led the way, mainly the Porsche 962 C. Nissan had entered seven cars, the models R90 and R89, which made pole position and fastest lap but could only make fifth overall. Twenty-four of the cars that finished the race (including the winner) did not cross the finish line due to the public invading the track.

1991 saw the return of Peugeot after an absence of fifty-three years. The winner, Mazda, was the first car to win the race fitted with carbon brakes. It was also the first and only appearance of Michael Schumacher at Le Mans, behind the wheel of a Sauber C11-Mercedes. He took the fastest lap of the race and finished in fifth place.

1992 saw a strong duel between Peugeot with the 905B and Toyota with the TS010 and 92C, final victory going to Peugeot, which was also the first victory for a V10 engine. The monocoque was carbon fibre and the bodywork had been optimised by Dassault Aviation, the company that builds the famous Mirage planes. Its drivers were Derek Warwick, Yannick Dalmas and Mark Blundell. A new circuit record was obtained with the pole of Philippe Alliot's Peugeot with a time of 3:23.209 (243.329km/h).

Much of the race was played out in heavy rain and in the final hours only the Mazda of the previous year's winners was able to give some opposition to the winning car. With the participation of only twenty-eight cars, this was the lowest entry list since 1934.

In 1993, Peugeot repeated the previous year's victory and not only got pole but the first three places, victory going to Geoff Brabham, Christophe Bounchut and Eric Hélary. The GTs returned but the winning Jaguar was disqualified for irregularities in the catalytic converter and the victory was handed over to Porsche.

With a 1994 victory for Dauer, Porsche obtained its thirteenth victory with a 962 converted into a GT by Jochen Dauer. It was also Honda's first participation with the NSX model of the GT class, ending in fourteenth, sixteenth and eighteenth positions. Dodge Viper entered Le Mans for the first time but could only manage to finish twelfth. Bugatti also returned with the EB110 after fifty-five years of absence and Ferrari participated for the first time since 1982. Derek Bell, five-time Le Mans winner, announced his retirement after twenty-six entries.

In McLaren's first entry in the 1995 Le Mans, the F1 was victorious in the hands of J.J. Lehto, Masanori Sekiya and Yannick Dalmas, placing four cars in the top five. Only the Courage Porsche split the McLarens, taking second place. McLaren's victory, meant it was the first team to win at Le Mans with a three-seater car. After twenty-one years, a Ferrari prototype appeared, the 333 SP, which failed to finish the race. At the same time, some F40 models participated, one of them taking twelfth place. Bell, despite having announced his retirement the year before, took part, again at the wheel of a McLaren F1 GTR, with his son Justin, having been third overall and second in the GT1 class.

1996 TWR Porsche driver Alexander Wurz, who won the race with Manuel Reuter and Davy Jones, was the youngest Le Mans winner at the age of 22. The surprise of the race came from Eric van de Poele who, behind the wheel of a Ferrari 333 SP, produced the fastest lap. Formula 1 World Champion Nelson Piquet entered the race and finished eighth overall.

For 1997, Joest Racing team's TWR Porsche had the same chassis and same No. 7 used by the previous year's winner as it did in 1984 and 1985. Albereto put the car on pole and went on to win with the help of Tom Kristensen and Stefan Johansson. The American car Panoz made its debut at Le Mans and the circuit underwent its eleventh change, increasing to 13,605km due to more modifications to the Dunlop curve. The Mello Breyner brothers finally qualified and finished eleventh overall and third in the GT2 class.

1998 saw six manufacturers with factory teams: Porsche, Toyota, Mercedes-Benz, Nissan, BMW and Chrysler. The average age of winners Allan McNish, Laurent Aïello and Stéphane Ortelli was 28.33 years, the lowest in the competition's history. It was the first all-Japanese podium, with third place overall for the Nissan R90 GT1, driven by Kazuyoshi Hoshino, Aguri Suzuki and Masahiko Kageyama.

BMW's first complete victory with the V12 LMR rounded off the 1990s, driven by Joachim Winkelhock, Pierluigi Martini and Yannick Dalmas. Mercedes' new version, the CLR, had stability and aerodynamic issues at high speeds, which resulted in the car somersaulting in the warm-up and qualifying. The team's management decided to withdraw before there was a serious accident.

1990 Silk Cut Jaguar — Group C1

 John **Nielsen** Price **Cobb** 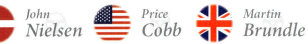 Martin **Brundle**

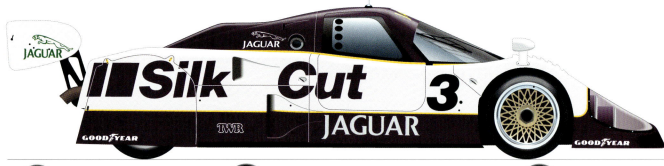

Jaguar XJR-12 LM Jaguar 7.0L V12 7000cc Goodyear

06 - 16-17

13 600 km

4882.400 km

AvS 204.036 km/h

Laps 359

Mark Blundell, Nissan R 90 CK
3'27.02" 236.450 km/h

Bob Earl, Nissan R 90 CK
3'40.03" 222.515 km/h

Other class winners	Drivers	Car
GTP	Takashi Yorino/Yoshimi Katayama/Yojiro Terada	Mazda 767 B
C2	Richard Piper/Olindo Iacobelli/Mike Youles	Spice SE89C - Ford Cosworth

84 LE MANS WINNING COLOURS

Group C2 — Mazdaspeed Co. Ltd. 🇯🇵 1991

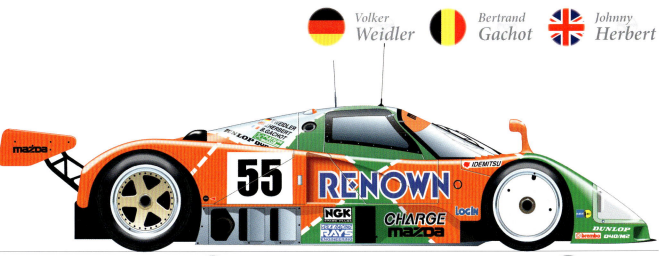

Volker Weidler 🇩🇪 | **Bertrand Gachot** 🇧🇪 | **Johnny Herbert** 🇬🇧

Mazda 787B | Mazda R26B 2.6L 4-Rotor 4708cc | Dunlop

📅 06-22-23 ☀

13 600 km

🏁 4922.810 km
AvS 205.333 km/h
Laps 362

🏁 Jean-Louis Schlesser, Sauber Mercedes C11 3'31.27" 231.741 km/h
⏱ Michael Schumacher, Sauber Mercedes C11 3'35.564" 227.125 km/h

Other class winners	Drivers	Car
1	Kiyoshi Misaki/Hisashi Yokoshima/Naoki Nagasaka	Spice SE90C-Ford Cosworth

1992 *Peugeot Talbot Sport* — Group C1

 Mark *Blundell* Yannick *Dalmas* Derek *Warwick*

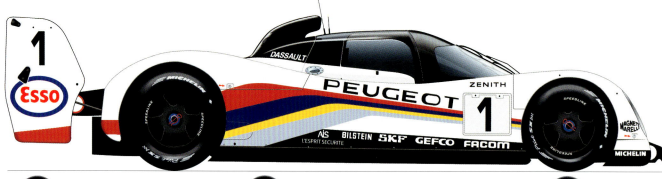

 Peugeot 905 Evo 1 Bis *Peugeot SA35 3.5L V10 3499cc* *Michelin*

 06 - 20 - 21

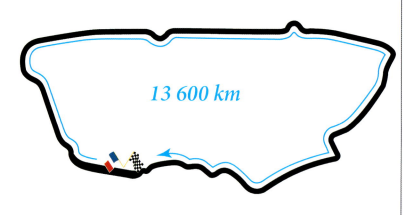
13 600 km

 4787.2 km

 AvS 199.34 km/h

 Laps 352

 Philippe Alliot, Peugeot 905
3'21.209" 243.329 km/h

 Jan Lammers, Toyota TS 010
3'32.295" 230.622 km/h

Other class winners	Drivers	Car
C2	Stefan Johansson/George Fouché/Steven Andskar	Toyota 92C-V
C3	Bob Wollek/Henri Pescarolo/Jean-Louis Ricci	Cougar C28LM - Porsche

Group C1 — Peugeot Talbot Sport 1993

 Christophe *Bouchut* Geoff *Brabham* Eric *Hélary*

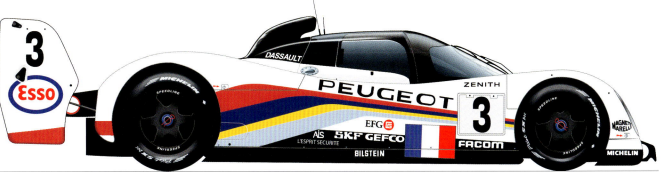

 Peugeot 905 Evo 1 Bis Peugeot SA35 3.5L V10 3499cc Michelin

 06 - 19-20

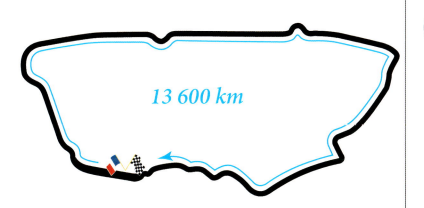 13 600 km

 5100.000 km

AvS 213.358 km/h

Laps 375

 Philippe Alliot, Peugeot 905
3'24.940" 238.899 km/h

 Eddie Irvine, Toyota TS 010
3'27.47" 235.986 km/h

Other class winners	Drivers	Car
C2	Roland Ratzenberger/Mauro Martini/Naoki Nagasaka	Toyota 93 C-V
C4	Jöel Gouhier/Jürgen Barth/Dominique Dupuy	Porsche Carrera RSR
C3	Patrick Gonin/Bernard Santal/Alain Lamouille	WR LM93 - Peugeot

1994 — Le Mans Porsche Team — LMGT1

 Mauro **Baldi**
 Yannick **Dalmas**
 Hurley **Haywood**

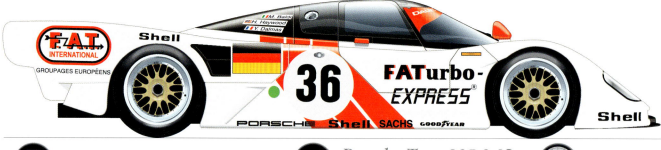

 Dauer 962 Le Mans-Porsche
 Porsche Type 935 3.0L Turbo F6 2994cc
 Goodyear

 06 - 18-19

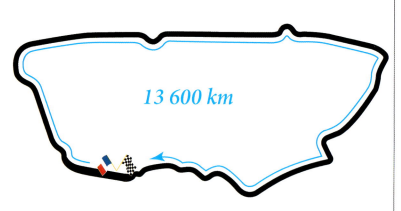 13 600 km

 4678.4 km
 AvS 195.264 km/h
 Laps 344

 Alain Ferté, Courage C32
3'51.050" 211.902 km/h

 Thierry Boutsen, Dauer-Porsche 962 LM
3'52.54" 210.544 km/h

Other class winners	Drivers	Car
LMP C/90	E. Irvine / J. Krosnoff / M. Martini	Toyota
IMSA / GTS	S. Millen / J. Morton / J. O'Connell	Nissan
LM GT2J.	Pareja / D. Dupuy / C. Palau	Porsche 911 Carrera RSR

LMGT1 *Kokusai Kaihatsu Racing* 1995

 Yannick *Dalmas* JJ *Lehto* Masanori *Sekiya*

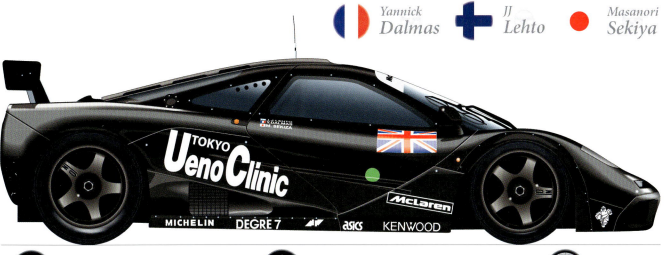

 McLaren F1 GTR-BMW BMW S70/2 6.1L V12 6064cc Michelin

 06 - 17-18

 4055.800 km

 AvS 168.992 km/h

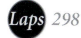 Laps 298

 13 600 km

 William David, WR LM94 3'46.050" 216.589 km/h

 Patrick Gonin, WR LM 94 3'51.41" 211.573 km/h

Other class winners	Drivers	Car
WSC	B. Wollek / Mario Andretti / E. Hélary	Courage C34 - Porsche
GT2	K. Tsuchiya / A. Iida / K. Takahashi	Honda NSX
LMP2	P. Roussel / E. Sezionale / B. Santal	Debora LMP - Ford

1996 Joest Racing — LMP1

 Davy **Jones** Alexander **Wurz** Manuel **Reuter**

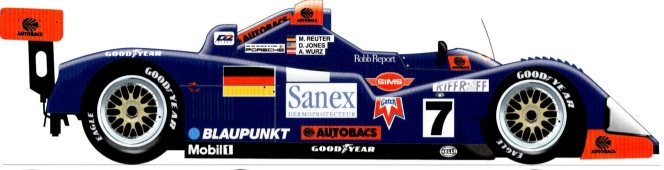

 TWR Porsche TWR Porsche WSC-95 2994cc Goodyear

 06 - 15-16

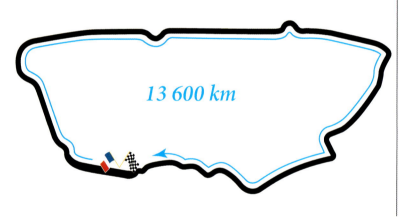

13 600 km

 4814.400 km

 AvS 200.600 km/h

 Laps 354

 Pierluigi Martini, TWR Porsche 3'46.682" 215.985 km/h Eric van der Poele, Ferrari 333 SP 3'46.958" 215.723 km/h

Other class winners	Drivers	Car
GT1	H.-J. Stuck Jr / T. Boutsen / B. Wollek	Porsche 911 GT1
GT2	G. Martinolle / R. Kelleners / B. Eichmann	Porsche 911 GT2
WSC / IMSA Y.	Terada / J. Downing / F. Fréon Kudzu	DLM - Mazda

LMP Joest Racing 1997

 Michele Alboreto Stefan Johansson Tom Kristensen

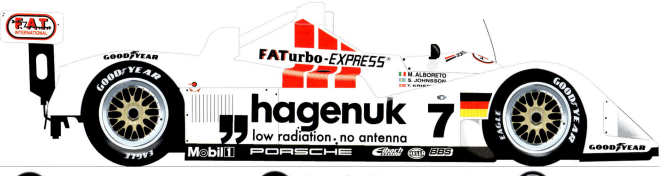

TWR Porsche WSC-95 | Porsche Type-935 3.0L Turbo F6 2994cc | Goodyear

06 - 14-15

13 605 km

 4909.600 km

AvS 204.261 km/h

Laps 361

 Michele Alboreto, TWR Porsche 3'41.581" 220.958 km/h

 Tom Kristensen, TWR Porsche 3'45.068" 217.534 km/h

Other class winners	Drivers	Car
GT1	J.-M. Gounon / P.-H. Raphanel / A. Olofsson	McLaren F1 GTR - BMW
GT2	M. Neugarten / G. Martinolle / J.-C. Lagniez	Porsche 911 GT2

1998 *Porsche AG* — *LMGT1*

 Laurent **Aiello** *Allan* **McNish** *Stephane* **Ortelli**

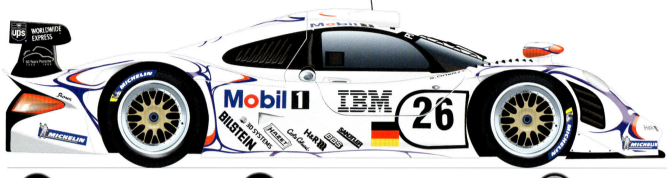

Porsche 911 GT1-98 *Porsche 3.2L Turbo F6 3196cc* *Michelin*

 06 - 06-07

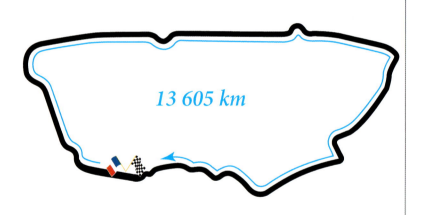

13 605 km

 4773.184 km

 AvS 199.321 km/h

 Laps 351

 Bernd Schneider, Mercedes CKL LM
3'35.544" 227.230 km/h

 Martin Brundle, Toyota GT ONE
3'41.809" 220.812 km/h

Other class winners	Drivers	Car
GT2	J. Bell / D. Donohue / L. Drudi	Chrysler Viper GTS-R
P1	W. Taylor / E. van der Poele / F. Velez	Ferrari 333 SP
P2	H. Pescarolo / O. Grouillard / F. Montagny	Courage C36 - Porsche

92 LE MANS WINNING COLOURS

LMP — Team BMW Motorsport 🇩🇪 1999

 Yannick **Dalmas** Pierluigi **Martini** Joachim **Winkelhock**

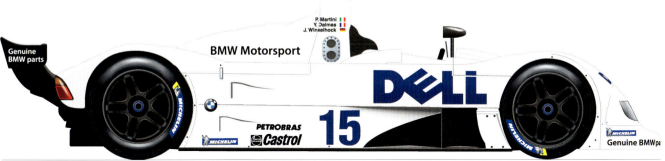

BMW V12 LMR **BMW 570 6.0L V12 5990cc** **Michelin**

06 - 12-13 ☀

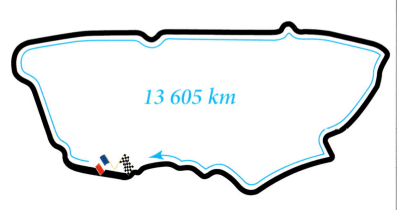

13 605 km

🇫🇷 ➡ 🏁 *4967.991 km*

AvS 207.624 km/h

Laps 365

P Martin Brundle, Toyota GT ONE 3'29"930 233.306 km/h

F Ukyo Katayama, Toyota GT ONE 3'35"032 227.771 km/h

Other class winners	Drivers	Car
LM GTP	U. Katayama / K. Tsuchiya / To. Suzuki	Toyota GT-ONE
GTS	O. Beretta / K. Wendlinger / D. Dupuy	Chrysler Viper GTS-R
GT	U. Alzen / P. Huismann / L. Riccitelli	Porsche 996

2000-2009

In only its second year of participating, Audi entered three cars in the 2000 Le Mans race, taking the first three positions on the grid, having the fastest lap of the race and finishing in the first three places. Victory went to Frank Biela, Emanuele Pirro and Tom Kristensen. This was a unique achievement: three consecutive victories for the same nation (Germany) but with three different marques – Porsche, BMW and Audi. After fifty years, Cadillac returned to Le Mans and Henri Pescarolo decided to hang up his helmet after thirty-three entries. His team, Pescarolo Sport, entered a Courage with a Peugeot engine, obtaining fourth place overall.

2001 saw another victory for Audi with the same team of Biela, Pirro and Kristensen as the previous year. It also managed second place. Jacky Ickx was nominated for Race Director, having started and shown the checkered flag, the first time that the respective honours had been given to the same person. Vanina Ickx, Jacky's daughter, participated for the first time behind the wheel of a Chrysler Viper. Bentley returned after an absence of seventy-one years; one of its cars finished the race with a victory in the LM GTP class and third place overall.

In 2002, for the third year running, victory fell to the Audi with the same trio of drivers – Biela, Pirro and Kristensen – who, with three cars entered at the official level, occupied the first three places, with the winning car making the hat-trick: victory, pole and fastest lap. A new modification to the track after the Dunlop bridge and the entry into the Bugatti circuit changed the length of the circuit to 13,650km. The Dutch marque Spyker entered for the first time but had to retire with engine problems.

2003 was the eightieth anniversary of the 24 Hours of Le Mans. Bentley took first and second places, with the winning car having led 370 of the 377 laps. This was the fourth consecutive win for Tom Kristensen and fifth win overall; he now equalled Derek Bell's record. For Bentley it was the sixth victory at Le Mans, the first being in 1924, followed by 1927, 1928, 1929 and 1930. Third and fourth places went to Audi; from the start of the race, the No. 10 Audi was the only car between the Bentleys until it ran out of fuel.

2004 saw victory for Audi and the Japanese Team Goh. The top two finished with just 41.354s between them. This race was the first entry of drivers from Russia and, at the age of 19, Adam Sharpe was the youngest driver to compete in the race. The Nazamax used a JUDD engine and was the first car to be powered by bio-ethanol, based on 95 per cent sugar from beets, sugar cane and potatoes.

2005 saw a seventh win for Tom Kristensen, again driving an Audi, beating Jacky Ickx's record.

In the 2006 race, although it won the LMP1 category, the Pescarolo C60s only managed second place, after a failed chase to take the breath away from the winning Audi, which made history by being the first diesel-engine car to win the 24 Hours of Le Mans. This race also saw the first all-French pole (car and driver) in ten years with drivers Henri Pescarolo and Jean-Christophe Boullion. Panoz obtained its only victory in the LMGT2. Emanuele Pirro set a new record by obtaining an eighth consecutive podium.

2007 saw the thirteenth circuit change: the distance was now 13,629km. Audi secured victory for a second time with a diesel engine, but this time it faced strong opposition from Peugeot, also with diesel cars. Porsche only entered four cars at the start, the smallest Porsche entry since 1963. Formula 1 World Champion Jacques Villeneuve entered the race for the first time but sadly retired, practically at the finish line, with engine problems. For the first time in the race, a system of coloured lights was used on the side of the cars, which indicated the position up to third place, depending on the category: LMP1 = red; LMP2 = blue; LMGT1 = green; LMGT2 = yellow.

By 2008, it looked as though diesel engines were here to stay, as Audi won yet again with the R10 Diesel, this time powered by biodiesel. This year's battle would be between three Audis and three Peugeots, and the difference between them was never more than two laps. The first six places were taken by the six diesel cars, with Tom Kristensen extending his winning record to eight. In terms of debuts Cong Fu Cheng became the first Chinese driver to compete.

In 2009, Peugeot took first and second place, with victory belonging to the car driven by David Brabham, Marc Gene and Alexander Wurz – Brabham was now Sir Jack Brabham's (former Formula 1 World Champion) second son to win at Le Mans, after Geoff Brabham in 1993. This year's race also saw two children and a nephew of former Formula 1 champions participate in the race – Nicolas Prost, Leo Mansell and Bruno Senna – and the ACO ruled that the temperature inside the passenger compartment must be placed at 32°C, forcing the teams to install air-conditioning in their cars.

2000 Audi Sport Team Joest — LMP900

 Frank **Biela** *Tom* **Kristensen** *Emanuele* **Pirro**

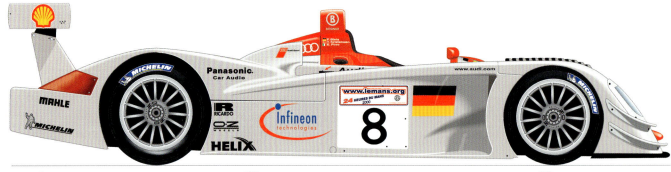

 Audi R8 Audi 3.6 L Turbo V8 Michelin

 06 - 17 - 18

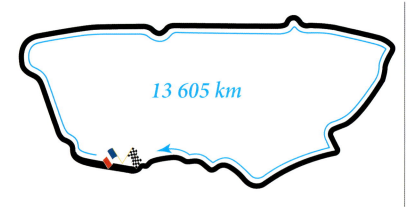

13 605 km

 → 5007.988 km

 AvS 209.176 km/h

 Laps 369

 337 km/h Panoz LMP1 Audi R8

 Allan McNish, Audi R8 3'36"124 226.620 km/h

 Allan McNish, Audi R8 3'37"359 225.332 km/h

Other class winners	Drivers	Car
LMGTS	Dominique Dupuy / Olivier Beretta / Karl Wendlinger	Chrysler Viper GTS-R
LMGT	Hideo Fukuyama / Atsushi Yogo / Bruno Lambert	Porsche 911 GT3-R
LMP675	Scott Maxwell / John Graham / Greg Wilkins	Lola B2K/40
		Porsche 996

LMP900 — Audi Sport Team Joest — 2001

 Frank Biela *Tom* Kristensen Emanuele Pirro

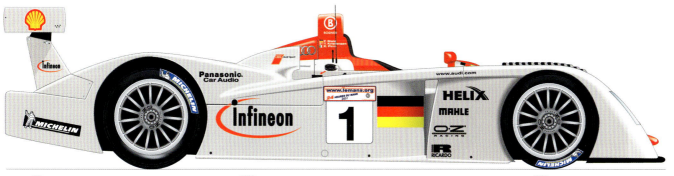

Audi R8 — Audi 3.6 L Turbo V8 — Michelin

06 - 16-17

13 605 km

4367.2 km
AvS 180.949 km/h
Laps 321
Bentley Speed 8 321 km/h

Rinaldo Capello, Audi R8
3'32"429 230.562 km/h

Laurent Aiello, Audi R8
3'39"046 223.597 km/h

Other class winners	Drivers	Car
LMGTP	Andy Wallace / Butch Leitzinger / Eric van de Poele	Bentley EXP Speed 8
LMP675	Jordi Gené / Jean-Denis Délétraz / Pascal Fabre	Reynard 2KQ-LM
LMGT	Gabrio Rosa / Fabio Babini / Luca Drudi	Porsche 911 GT3-RS
LMGTS	Ron Fellows / Scott Pruett / Johnny O'Connell	Chevrolet Corvette C5-R

2002 — Audi Sport Team Joest — LMP900

 Frank **Biela** *Tom* **Kristensen** *Emanuele* **Pirro**

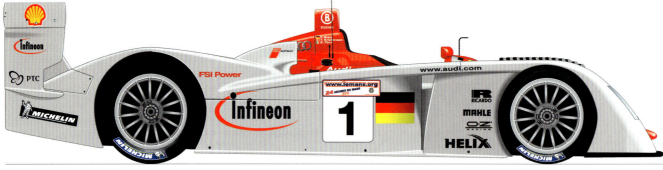

 Audi R8 Audi 3.6 L Turbo V8 Michelin

 06 - 15 - 16

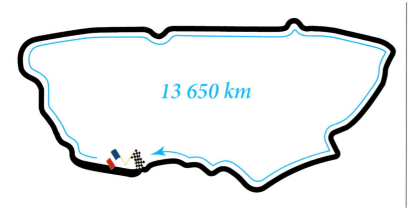 13 650 km

 → 5118.75 km
 AvS 213.067 km/h
Laps 375
 Audi R8 339 km/h

 Rinaldo Capello, Audi R8
3'29"905 234.106 km/h

 Tom Kristensen, Audi R8
3'33"483 230.182 km/h

Other class winners	Drivers	Car
LMGTP	Andy Wallace / Eric van de Poele / Butch Leitzinger	Bentley EXP Speed 8
LMGTS	Ron Fellows / Johnny O'Connell / Oliver Gavin	Chevrolet Corvette C5-R
LMGT	Kevin Buckler / Lucas Luhr / Timo Bernhard	Porsche 911 GT3-RS
LMP675	Jean-Denis Délétraz / Christophe Pillon / Walter Lechner, Jr	Reynard 2KQ-LM

LE MANS WINNING COLOURS

LMGTP Team Bentley 2003

Rinaldo **Capello** *Tom* **Kristensen** *Guy* **Smith**

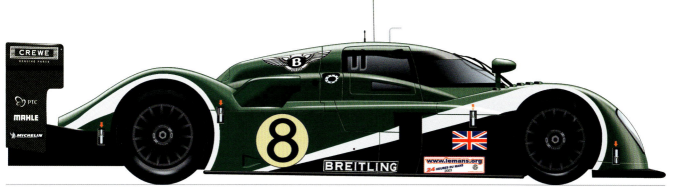

Bentley Speed 8 Bentley 4.0 L Turbo V8 Michelin

06 - 14-15

13 650 km

5145.571 km

AvS 214.317 km/h

Laps 377

Dome S101 327 km/h

Tom Kristensen, Bentley Speed 8
3'32"843 230.874 km/h

Johnny Herbert, Bentley Speed 8
3'35"529 227.997 km/h

Other class winners	Drivers	Car
LMP900	JJ Lehto / Emanuele Pirro / Stefan Johansson	Audi R8
GTS	Tomáš Enge / Peter Kox / Jamie Davies	Ferrari 550-GTS Maranello
LMP675	Jean-Luc Maury-Laribière / Christophe Pillon / Didier André	Reynard 2KQ-LM

2004 — Audi Sport Japan Team Goh — LMP1

Seiji **Ara** — *Rinaldo* **Capello** — *Tom* **Kristensen**

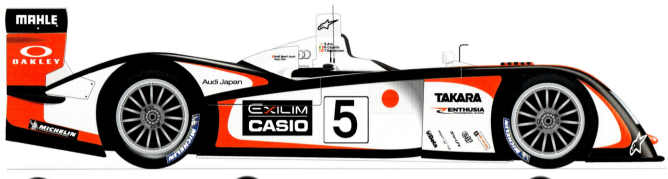

 Audi R8 Audi 3.6 L Turbo V8 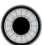 Michelin

 06 - 12-13

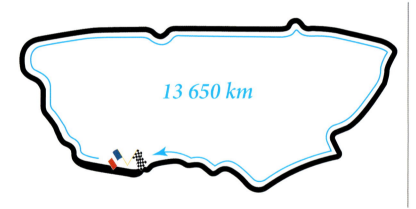

13 650 km

 5169.97 km

 AvS 215.418 km/h

 Laps 379

 Dome S101, Audi R8, Pescarolo C60
3'39"046 325.597 km/h

 Johnny Herbert, Audi R8
3'32"838 230.880 km/h

 Jamie Davis, Audi R8
3'34"264 229.343 km/h

Other class winners	Drivers	Car
GTS	Oliver Gavin / Olivier Beretta / Jan Magnussen	Chevrolet Corvette C5-R
GT	Jörg Bergmeister / Patrick Long / Sascha Maassen	Porsche 911 GT3-RS
LMP2	William Binnie / Clint Field / Rick Sutherland	Lola B2K/40

LMP1	ADT Champion Racing	2005

 JJ **Lehto** *Tom* **Kristensen** *Marco* **Werner**

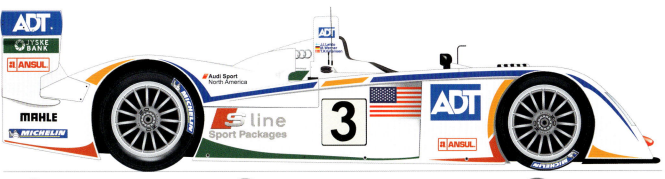

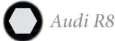 Audi R8 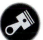 Audi 3.6 L Turbo V8 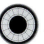 Michelin

 06-18-19

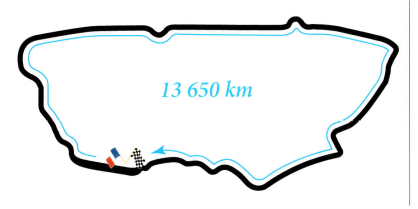

13 650 km

 5050.97 km

 210.216 km/h

 370

 Pescarola C60 309 km/h

 Emmanuel **Collard**, *Pescarola C60*
3'34"715 228.862 km/h

 Jean-Christophe **Boullion**, *Pescarolo C60*
3'34"968 228.592 km/h

Other class winners	Drivers	Car
GT1	Oliver Gavin / Olivier Beretta / Jan Magnussen	Chevrolet Corvette C6-R
GT2	Mike Rockenfeller / Marc Lieb / Leo Hindery	Porsche 911 GT3-RSR
LMP2	Thomas Erdos / Mike Newton / Warren Hughes	MG-Lola EX264

2006 Audi Sport Team Joest — LMP1

 Frank *Biela* Emanuele *Pirro* Marco *Werner*

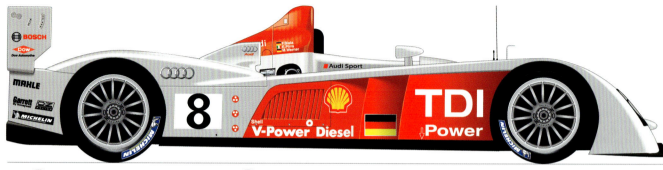

 Audi R10 Audi TDI 5.5L Turbo V12 Michelin

 06 - 17-18

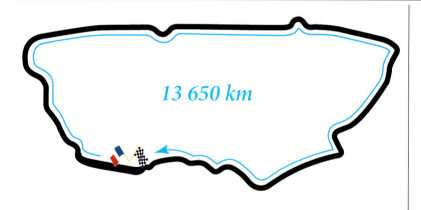

13 650 km

 5187.00 km

 AvS 215.408 km/h

 Laps 380

 Pescarolo C60 315 km/h

 Frank Montagny, Pescarolo C60
3'30"195 233.783 km/h

 Tom Kristensen, Audi R10 TDI
3'31"211 232.658 km/h

Other class winners	Drivers	Car
GT1	Oliver Gavin / Olivier Beretta / Jan Magnussen	Chevrolet Corvette C6-R
LMP2	Mike Newton / Thomas Erdos / Andy Wallace	MG-Lola EX264
GT2	Lawrence Tomlinson / Tom Kimber-Smith / Richard Dean	Panoz Esperante GT-LM

LMP1 Audi Sport North America 2007

 Frank *Biela* Emanuele *Pirro* Marco *Werner*

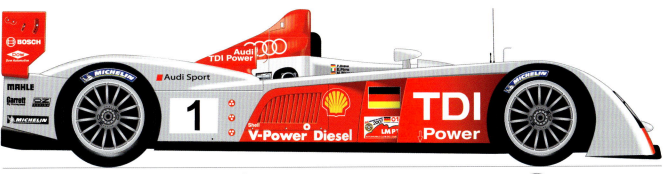

 Audi R10 TDI Audi TDI 5.5L Turbo V12 (Diesel) Michelin

 06 - 16-17

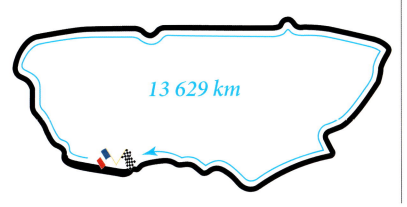 13 629 km

 → 5029.101 km

 AvS 209.152 km/h

 Laps 369

 Audi R10 TDI 337 km/h

 Stéphane Sarrazin, Peugeot 908 HDi-FAP 3'36"344 237.780 km/h

 Allan McNish, Audi R10 TDI 3'27"176 236.825 km/h

Other class winners	Drivers	Car
GT1	David Brabham / Darren Turner / Rickard Rydell	Aston Martin DBR9
GT2	Raymond Narac / Richard Lietz / Patrick Long	Porsche 997 GT3-RSR
LMP2	William Binnie / Allen Timpany / Chris Buncombe	Lola B05/42

2000-2009 103

2008 Audi Sport North America — LMP1

 Rinaldo **Capello** — Tom **Kristensen** — Allan **McNish**

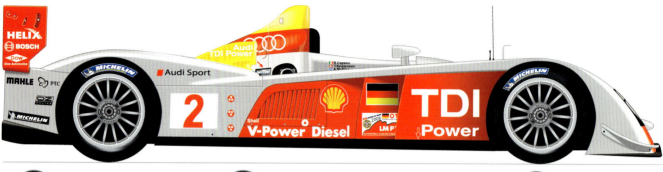

 Audi R10 TDI Audi TDI 5.5L Turbo V12 (Diesel) Michelin

 06 - 14-15

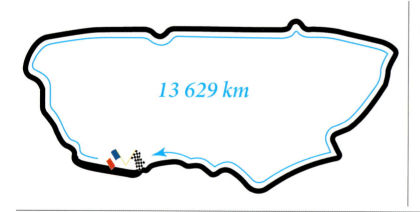

13 629 km

 5192.649 km

 AvS 216.300 km/h

 Laps 381

 Peugeot 908 HDI- FAP 337 km/h

 Stéphane Sarrazin, Peugeot 908 HDi-FAP 3'18"513 247.160 km/h

 Stéphane Sarrazin, Peugeot 908 3'19"394 246.068 km/h

Other class winners	Drivers	Car
LMP2	Peter van Merksteijn / Jeroen Bleekemolen / Jos Verstappen	Porsche RS Spyder Evo
GT1	David Brabham / Antonio García / Darren Turner	Aston Martin DBR9
GT2	Gianmaria Bruni / Mika Salo / Jaime Melo	Ferrari F430 GT2

104 LE MANS WINNING COLOURS

LMP1 — *Peugeot Sport Total* 2009

 David **Brabham**　 Marc **Gené**　Alexander **Wurz**

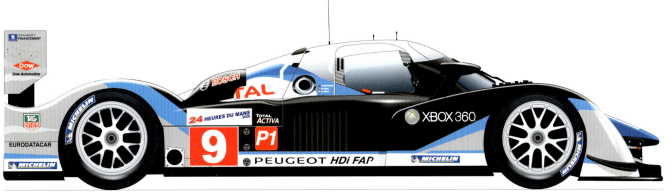

Peugeot 908 HDi FAP　Peugeot 908 HDi 5.5L Turbo V12　Michelin

06 - 13-14

 13 629 km

5206.278 km
AvS 216.663 km/h
Laps 382
Peugeot 908 HDi-FAP 343 km/h

Stéphane Sarrazin, Peugeot 908 HDi-FAP 3'22"888 241.830 km/h

Nicolas Minassian, Peugeot 908 HDi-FAP 3'24"352 240.097 km/h

Other class winners	Drivers	Car
LMP2	Casper Elgaard / Kristian Poulsen / Emmanuel Collard	Porsche RS Spyder Evo
GT1	Johnny O'Connell / Jan Magnussen / Antonio García	Chevrolet Corvette C6.R
GT2	Jaime Melo / Pierre Kaffer / Mika Salo	Ferrari F430 GT2

2010–2019

In 2010, Audi equalled Ferrari's record of nine victories and Ford returned to Le Mans with the GT, the descendant of the mythical GT40 in LMGT2; the victory in this category went to Porsche in its sixtieth consecutive entry in the race. BMW participated with an ART car decorated by American Jeff Koons. 2010 also saw the first participation of a team made up of a father and his two sons – former Formula 1 World Champion Nigel Mansell with his sons Greg and Leo.

In 2011, Allan McNish survived a spectacular accident in the first hour of the race when he tried to overtake his teammates Timo Bernhard and Anthony Beltoise, who were driving the Ferrari 458 Italia, at the same time. It was a hat-trick for Audi, which not only secured pole position and fastest lap but went on to win the race. It was also the first time a couple had entered the race: David and Andrea Robertson participated behind the wheel of a Ford GT40.

The eightieth anniversary of the 24 Hours of Le Mans in 2012 saw victory once again with an Audi. This time with yet another technical innovation: the winning Audi R18 e-tron quattro was equipped, in addition to the V6 TDI diesel engine, with two electric motors mounted on the front axle and a flywheel, which, together with the 510hp of the diesel engine, had 200hp more on the front wheels, making it the first hybrid and four-wheel drive vehicle to win at Le Mans. Toyota also entered a hybrid model – an electric motor mounted on the rear axle. Another new entry was the Delta Wing, which was running well until it was forced to withdraw due to a collision with a Toyota.

In 2013, it was another victory for Audi with the R18 e-tron quattro and Tom Kristensen increased his personal record to nine victories. For the first time the top five cars were hybrid vehicles: three Audis and two Toyotas. All of the practice sessions were interrupted by red flags (six in all) due to accidents caused by bad weather.

2014 saw the record for the youngest driver beaten by Matthew McMurry, who, at the age of 16 years and 202 days, dethroned Ricardo Rodríguez, who had held the record since 1959.

In 2015, the Porsche 919 hybrid emerged as a very real threat to Audi; it made good on its threat by taking the win with drivers Nico Hülkenberg, Earl Bamber and Nick Tandy.

2016 saw the Porsche victory no one expected. With ten minutes to go in the race, the Porsche No. 2 had to pit because of a puncture, but with six minutes to go, the current leader of the race, Toyota No. 5, lost power and stopped right after it reached the finish line, handing the victory over to Porsche. For the first time in history, the race started with the safety car to allow the track to be cleared of water after heavy rainfall just before the start of the race. This was the first time since 1955 that sixty cars formed the starting grid.

In 2017 the regulations were changed: a team would no longer be disqualified if the time of the last lap exceeded six minutes, as had happened previously. The third-placed Vaillante Rebellion was disqualified because the team made a hole in the body so that the mechanics could start the ignition using a wrench and hammer. After stopping for just over an hour and dropping to fifty-fifth place, Porsche made a fantastic comeback to take the lead with an hour and a half of the race left and secure a victory. For the first time an LMP2 led the race; this feat was made possible by the Oreca of Jackie Chan DC Racing. In the LM GTE Pro, the battle was open until the penultimate lap when the frontrunner in the Corvette lost the lead, due to a puncture, to the Aston Martin and the Ford, and dropped to third place.

2018 saw the start line advance 145m but the finish line remain in the same place. This was so that cars were not starting the race around the Ford curves. Fernando Alonso took another step towards winning the Triple Crown by being part of the winning trio of Sébastien Buemi and Kazuki Nakajima driving the Toyota TS050.

2019 saw a new record of participants: sixty-two. During the first qualifying session, Toyota No. 7 collided with the Oreca at the entrance to the home straight, having fractured the chassis; a new chassis was used for subsequent qualifying sessions. Victory once again belonged to Toyota; however, this victory was not the car that deserved to win. One hour from the end the lead car pitted with a puncture, and upon leaving the pits the driver was informed that he had another puncture, so he had to lap at a slower pace to make it back to the pits. This put Toyota No. 8, with the trio of Buemi, Alonso and Nakajima, into the lead and go on to take a second consecutive victory. In the LMGTE Am, victory initially went to the Ford GT but it would later be disqualified, due to the fuel tank not being regulated. The beneficiary of this disqualification was the ART car of Team Project 1 with Jörg Bergmeister, Patrick Lindsey and Egidio Perfetti driving.

2010 Audi Sport North America — LMP1

 Timo **Bernhard** *Romain* **Dumas** *Mike* **Rockenfeller**

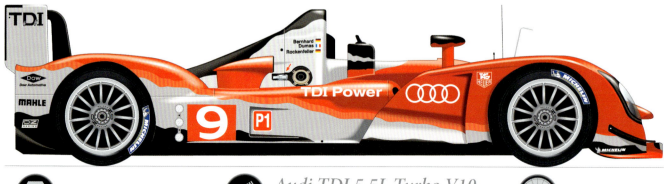

 Audi R15 TDI Plus Audi TDI 5.5L Turbo V10 (Diesel) Michelin

 06 - 12-13

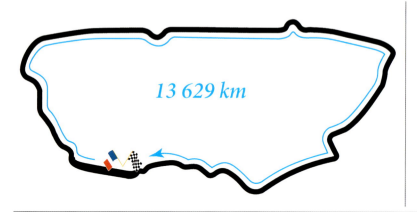

13 629 km

 5410.713 km

 225.228 km/h

 397

 Peugeot 908 HDi-FAP 331 km/h

 Sébastien Bourdais, Peugeot 908 HDi-FAP 3'19"711 245.677 km/h

 Loic Duval, Peugeot 908 HDi-FAP 3'19"074 246.463 km/h

Other class winners	Drivers	Car
LMP2	Nick Leventis / Danny Watts / Jonny Kane	HPD ARX-01C
LMGT2	Marc Lieb / Richard Lietz / Wolf Henzler	Porsche 997 GT3-RSR
LMGT1	Roland Berville / Julien Canal / Gabriele Gardel	Saleen S7-R

LMP1 — Audi Sport Team Joest — 2011

 Marcel *Fässler* André *Lotterer* Benoît *Tréluyer*

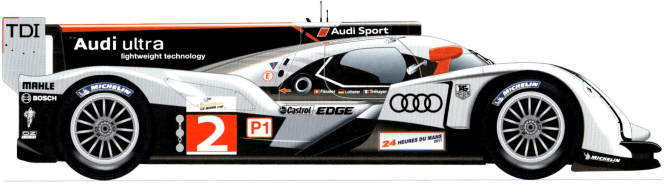

 Audi R18 TDI Audi TDI 3.7L Turbo V6 (Diesel) Michelin

 06 - 11 - 12

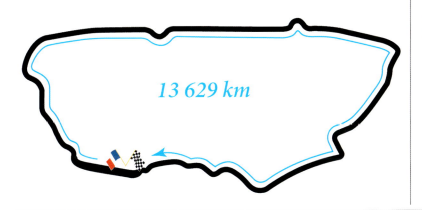 13 629 km

 → 4838.295 km

AvS 201.265 km/h

Laps 355

 Peugeot 908 342.9 km/h

 Benoît Treluyer, Audi R18 TDI 3'25"783 238.480 km/h

 André Lotterer, Audi R18 TDI 3'25"289 239.001 km/h

Other class winners	Drivers	Car
LMP2	Karim Ojjeh / Olivier Lombard / Tom Kimber-Smith	Zytek Z11SN
LMGTE Pro	Olivier Beretta / Tommy Milner / Antonio García	Corvette C6.R
LMGTE Am	Patrick Bornhauser / Julien Canal / Gabriele Gardel	Corvette C6.R

2012 — Audi Sport Team Joest — LMP1

 Marcel *Fässler*
 André *Lotterer*
 Benoît *Tréluyer*

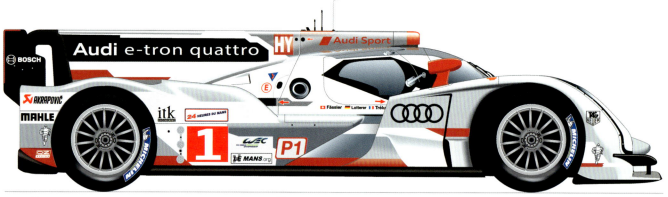

 Audi R18 e-tron quattro Audi TDI 3.7L Turbo V6 (Hybrid Diesel) Michelin

 06 - 16 - 17

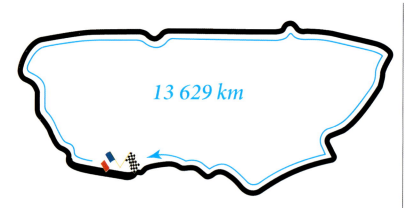

13 629 km

 → 5151.762 km
 AvS 214.467 km/h
 Laps 378
 Toyota 030 Hybrid 332.1 km/h

 André Lotterer, Audi R18 e-tron quattro
3'23"787 240.763 km/h

 Loïc Duval, Audi R8 ultra
3'24"189 240.289 km/h

Other class winners	Drivers	Car
LMP2	Enzo Potolicchio / Ryan Dalziel / Tom Kimber-Smith	HPD ARX-03b
LMGTE Pro	Giancarlo Fisichella / Gianmaria Bruni / Toni Vilander	Ferrari 458 Italia GT2
LMGTE Am	Patrick Bornhauser / Julien Canal / Pedro Lamy	Chevrolet Corvette C6.R

LMP1 — Audi Sport Team Joest — 2013

Loïc **Duval** — Tom **Kristensen** — Allan **McNish**

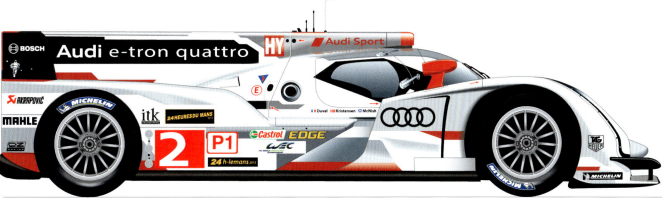

- Audi R18 e-tron quattro
- Audi TDI 3.7L Turbo V6 (Hybrid Diesel)
- Michelin

06 - 22-23

13 629 km

- 4742.892 km
- AvS 197.445 km/h
- Laps 348
- Audi R18 e-tron quattro 330.8 km/h

Loïc Duval, Audi R18 e-tron quattro 3'22"349 242.474 km/h

André Lotterer, Audi R18 e-tron 3'22"746 241.999 km/h

Other class winners	Drivers	Car
LMP2	Bertrand Baguette / Martin Plowman / Ricardo González	Morgan LMP2
LMGTE Pro	Marc Lieb / Richard Lietz / Romain Dumas	Porsche 911 RSR
LMGTE Am	Raymond Narac / Christophe Bourret / Jean-Karl Vernay	Porsche 911 GT3 RSR

2014 Audi Sport Team Joest — LMP1

 Marcel **Fässler**

 André **Lotterer**

Benoît **Tréluyer**

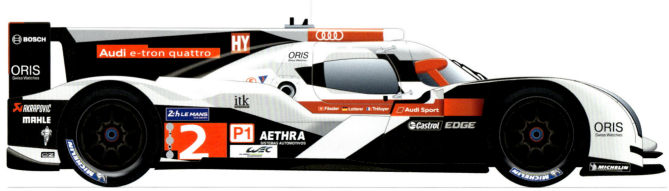

Audi R18 e-tron quattro — *Audi DTI 4.0L Turbo V6 (Hybrid Diesel)* — *Michelin*

📅 06 - 14-15

13 629 km

5165.391 km

AvS 214.926 km/h

Laps 379

Audi R18 e-tron quattro 339.100 km/h

Kazuki Nakajima, Toyota TSC40 Hybrid 3'21"789 243.147 km/h

André Lotterer, Audi R18 e-tron 3'22"567 242.213 km/h

Other class winners	Drivers	Car
LMP2	Simon Dolan / Harry Tincknell / Oliver Turvey	Zytek Z11SN
LMGTE Pro	Gianmaria Bruni / Giancarlo Fisichella / Toni Vilander	Ferrari 458 Italia GT2
LMGTE Am	David Heinemeier Hansson / Kristian Poulsen / Nicki Thiim	Aston Martin V8 Vantage GTE

LMP1 — Porsche Team 🇩🇪 2015

 Earl *Bamber* Nico *Hülkenberg* Nick *Tandy*

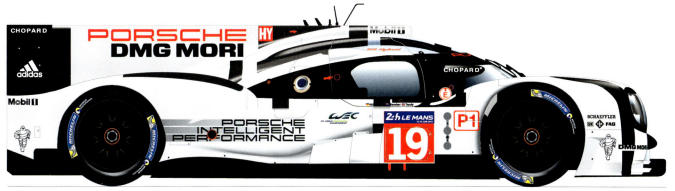

 Porsche 919 Hybrid *Porsche 2.0L Turbo V4* *Michelin*

 06 - 13 - 14

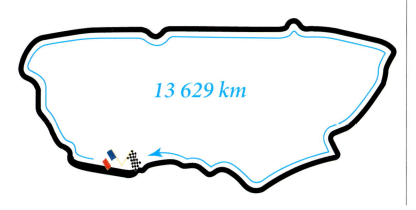

13 629 km

5382.82 km

AvS 224.199 km/h

Laps 395

Audi R18 e-tron quattro
345.6 km/h

 Neel Jani, Porsche 919 Hybrid
3'16"887 249.200 km/h

 André Lotterer, Audi R18 e-tron
3'17"475 248.458 km/h

Other class winners	Drivers	Car
LMP2	Matthew Howson / Richard Bradley / Nicolas Lapierre	Oreca 05
LMGTE Pro	Oliver Gavin / Tommy Milner / Jordan Taylor	Chevrolet Corvette C7.R
LMGTE Am	Viktor Shaytar / Aleksey Basov / Andrea Bertolini	Ferrari 458 Italia GT2

2016 Porsche Team — LMP1

 Romain *Dumas* Neel *Jani* Marc *Lieb*

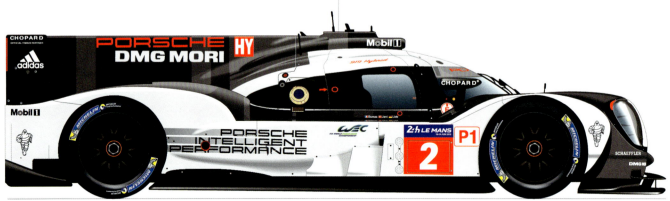

Porsche 919 Hybrid | Porsche 2.0L Turbo V4 | Michelin

06 - 18-19

13 629 km

5233.536 km
AvS 217.967 km/h
Laps 384
Rebellion R ONE 338.100 km/h

Neel Jani, Porsche 919 Hybrid
3'19"733 245.649 km/h

Kamui Kobayashi, Toyota TS050 Hybrid 3'21"445 243.562 km/h

Other class winners	Drivers	Car
LMP2	Nicolas Lapierre / Gustavo Menezes / Stéphane Richelmi	Alpine A460
LMGTE Pro	Joey Hand / Dirk Müller / Sébastien Bourdais	Ford GT
LMGTE Am	Bill Sweedler / Townsend Bell / Jeff Segal	Ferrari 458 Italia GT2

114 LE MANS WINNING COLOURS

LMP1 *Porsche LMP Team* *2017*

 Earl **Bamber** *Timo* **Bernhard** *Brendon* **Hartley**

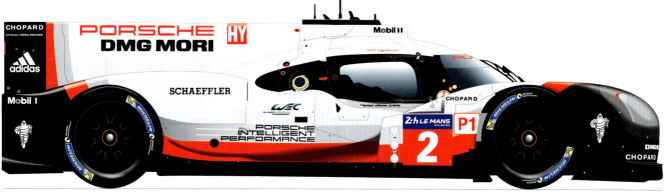

 Porsche 919 Hybrid *Porsche 2.0L Turbo V4* *Michelin*

 06 - 17 - 18

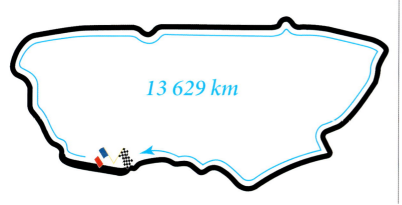

13 629 km

 → 5001.23 km

 AvS 208.153 km/h

 Laps 367

 Porsche 919 Hybrid
334.900 km/h

 Kamui Kobayashi, Toyota TS50 Hybrid
3'14"791 251.882 km/h

 Sebastien Buemi, Toyota TS050
3'18"604 247.046 km/h

Other class winners	Drivers	Car
LMP2	Ho-Pin Tung / Thomas Laurent / Oliver Jarvis	Oreca 07
LMGTE Pro	Darren Turner / Jonathan Adam / Daniel Serra	Aston Martin Vantage GTE
LMGTE Am	Robert Smith / Will Stevens / Dries Vanthoor	Ferrari 488 GTE

2018 Toyota Gazoo Racing — LMP1

 Fernando *Alonso* Sébastien *Buemi* Kazuki *Nakajima*

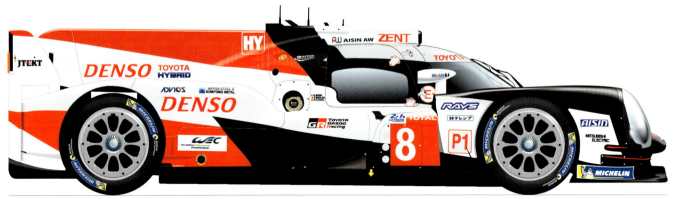

 Toyota TS050 Hybrid Toyota 2.4L Turbo V6 Michelin

 06 - 16-17

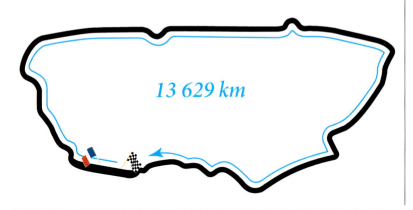

13 629 km

 5286.888 km

 AvS 220.153 km/h

 Laps 388

 Alpine A470 343.400 km/h

 Kazuki Nakajima, Toyota TS050 Hybrid 3'15"377 251.200 km/h

 Sébastien Buemi, Toyota TS050 Hybrid 3'17"658 248.228 km/h

Other class winners	Drivers	Car
LMP2	Nicolas Lapierre / Pierre Thiriet / André Negrão	Alpine A470
LMGTE Pro	Michael Christensen / Kévin Estre / Laurens Vanthoor	Porsche 911 RSR
LMGTE Am	Matt Campbell / Christian Ried / Julien Andlauer	Porsche 911 RSR

LMP1 — Toyota Gazoo Racing 2019

 Fernando *Alonso* Sébastien *Buemi* Kazuki *Nakajima*

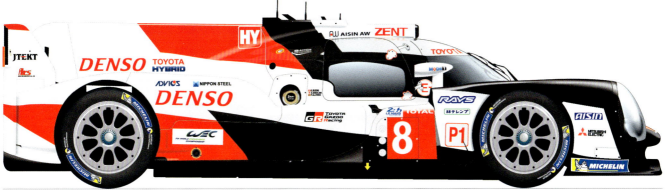

 Toyota TS050 Hybrid Toyota 2.4L Turbo V6 Michelin

 06 - 15-16

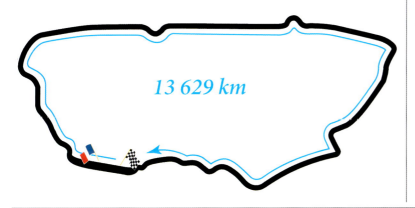

13 629 km

 5246.01 km

AvS 218.557 km/h

Laps 385

 BR BR1 350.100 km/h

 Kamui Kobayashi, Toyota TS050 Hybrid 3'15"497 244.700 km/h

 Mike Conway, Toyota TS050 Hybrid 3'17"297 248.682 km/h

Other class winners	Drivers	Car
LMP2	Nicolas Lapierre / Pierre Thiriet / André Negrão	Alpine A470
LMGTE Pro	James Calado / Alessandro Pier Guidi / Daniel Serra	Ferrari 488 GTE Evo
LMGTE Am	Jörg Bergmeister / Patrick Lindsey / Egidio Perfetti	Porsche 911 RSR

2020-2023

As a result of the COVID-19 global pandemic and government guidelines, the eighty-eighth edition of the 24 Hours of Le Mans in 2020, initially scheduled for 13/14 June, was postponed until 19/20 September. On 10 August, it was announced that the competition would take place without spectators and with a very limited number of journalists. For the first time, a new qualifying format, known as the Hyperpole, was used to define the starting grid (this is for the first six qualifiers in each class; the outcome determines the top six places in each class on the starting grid). Toyota won once again, this time with drivers Sebastian Buemi, Kabuki Nakajima and Brendon Hartley. The car from Jackie Chan DC Racing was disqualified when Gabriel Aubry stopped on the track, used his phone and asked the team for help via WhatsApp. A mechanic went to the stricken car to install a part, which resulted in instant disqualification.

In 2021, with COVID-19 more controlled, an attendance of 50,000 spectators was authorised. As in 2016, the start took place with the safety car on track for two laps due to the heavy rain that had occurred earlier. Along with the announcement of the new TotalEnergies biofuel, the ACO announced that a hydrogen class will debut in 2025. During the Hyperpole, the Porsche 92 suffered an accident on its first lap, the car being damaged beyond repair, which forced a chassis change, so did not obtain a time. In the race Toyota went on to win with the new GR010 with drivers Mike Conway, Kamui Kobayashi and José María López. In the most popular class, LMP2, the leading Oreca of Team WRT was forced to retire on the track due to a broken throttle sensor, handing victory to the other Team WRT car. The agreement between the ACO and IMSA through its presidents (Pierre Fillon, Jim France and John Doonan) resulted in the renaming of the first chicane to 'Daytona Chicane', and at Daytona the renowned 'Bus Stop' chicane would now be known as 'Le Mans Chicane'.

The 2022 victory went to Toyota for a fifth consecutive time, with drivers Sébastian Buemi, Brendon Hartley and Ryo Hirakawa. In the LMP2 category, victory went to JOTA, with drivers Roberto González, António Félix da Costa and Will Stevens. Still in LMP2, but in the Pro/AM class, victory went to Algarve Racing. And here's a curious fact relating to this victory: due to an accident in the first free practice session, the chassis was destroyed and they had to resort to a new chassis. They did not participate in the qualifying and started the race at the back of the grid with no qualifying time.

The 2023 race has not yet been run at the time of writing.

LMP1 — Toyota Gazoo Racing 2020

 Sébastien **Buemi** Brendon **Hartley** Kazuki **Nakajima**

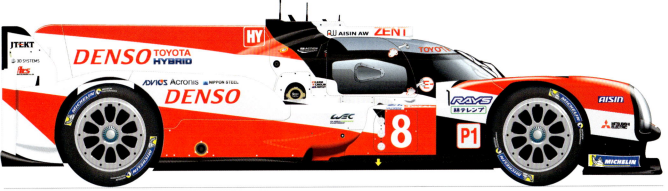

 Toyota TS050 Hybrid Toyota 2.4L V6 Turbo Hybrid Michelin

 09-19-20

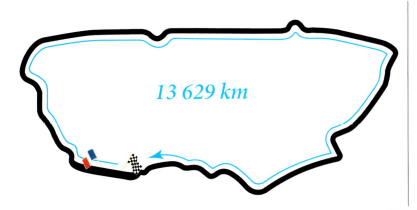 13 629 km

 → 5272.46 km

 AvS 219.451 km/h

 Laps 387

 Rebellion R13 347.800 km/h

 Kamui Kobayashi, Toyota TS050 3'15"267 251.200 km/h

 Bruno Senna, Oreca 07 3'19"274 234.282 km/h

Other class winners	Drivers	Car
LMP2	Filipe Albuquerque / Philip Hanson / Paul di Resta	Oreca 07
LMGTE Pro	Alex Lynn / Maxime Martin / Harry Tincknell	Aston Martin Vantage AMR
LMGTE Am	Jonathan Adam / Charlie Eastwood / Salih Yoluç	Aston Martin Vantage AMR

2021 Toyota Gazoo Racing — *Hypercar*

 Mike **Conway** Kamui **Kobayashi** José María **López**

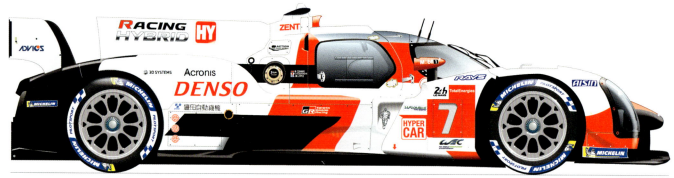

 Toyota GR010 Hybrid Toyota 2.5L V6 Twin Turbo Hybrid Michelin

 08 - 21-22

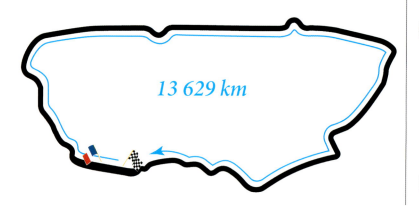 13 629 km

 5054.5 km

AvS 210.511 km/h

Laps 371

 Toyota GR010 399.100 km/h

 Kamui Kobayashi, Toyota GR010 3'32"900 240.600 km/h

 Brendon Hartley, Toyota GR010 Hybrid 3'27"607 236.333 km/h

Other class winners	Drivers	Car
LMP2	Robin Frijns / Ferdinand von Habsburg / Charles Milesi	Oreca 07
LMP2 (Pro-Am)	Henrik Hedman / Ben Hanley / Juan Pablo Montoya	Oreca 07
GTE Pro	James Calado / Alessandro Pier Guidi / Côme Ledogar	Ferrari 488 GTE Evo
GTE Am	Nicklas Nielsen / François Perrodo / Alessio Rovera	Ferrari 488 GTE Evo
Innovative	Takuma Aoki / Nigel Bailly / Matthieu Lahaye	Oreca 07

LE MANS WINNING COLOURS

Hypercar — Toyota Gazoo Racing 2022

Sébastien **Buemi** Brendon **Hartley** Ryō **Hirakawa**

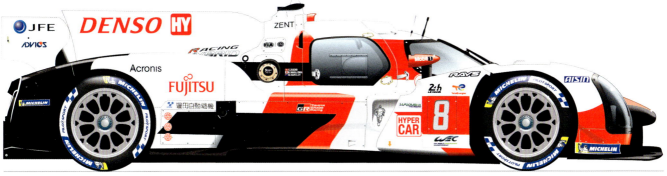

 Toyota GR010 Hybrid Toyota 3.5L V6 Twin Turbo Hybrid Michelin

 06 - 11 - 12

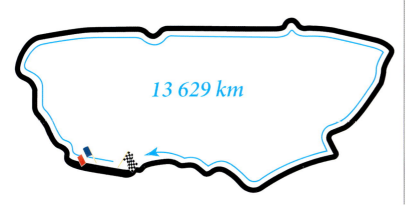
13 629 km

 → 5177.17 km

AvS 215.425 km/h

Laps 380

 Toyota GR010 342.100 km/h

 Brendon Hartley, Toyota GR010 Hybrid 3'24"408 240.000 km/h

 José María López, Toyota GR010 Hybrid 3'27"749 236.171 km/h

Other class winners	Drivers	Car
LMP2	Roberto González / António Félix da Costa / Will Stevens	Oreca 07
LMP2 (Pro-Am)	Steven Thomas / James Allen / René Binder	Oreca 07
GTE Pro	Gianmaria Bruni / Richard Lietz / Frédéric Makowiecki	Porsche 911 RSR-19
GTE Am	Ben Keating / Henrique Chaves / Marco Sørensen	Aston Martin Vantage AMR

2020-2023

Most Wins by Driver	Rank	Wins	Driver/Nat	Years
	1	9	Tom Kristensen 🇩🇰	1997, 2000, 2001, 2002, 2003, 2004 2005, 2008, 2013
	2	6	Jacky Ickx 🇧🇪	1969, 1975, 1996, 1977, 1981, 1982
	3	5	Derek Bell 🇬🇧	1975, 1981, 1982, 1986, 1987
			Frank Biela 🇩🇪	2000, 2001, 2002, 2006, 2007
			Emanuele Pirro 🇮🇹	2000, 2001, 2002, 2006, 2007
	6	4	Olivier Gendebien 🇧🇪	1958, 1960, 1961, 1962
			Henri Pescarolo 🇫🇷	1972, 1973, 1974, 1984
			Yannick Dalmas 🇫🇷	1992, 1994, 1995, 1999
			Sebastien Buemi 🇨🇭	2018, 2019, 2020, 2022
	9	3	Woolf Barnato 🇬🇧	1928, 1929, 1930
			Luigi Chinetti 🇮🇹	1932, 1934, 1949
			Phil Hill 🇺🇸	1958, 1961, 1962
			Hurley Haywood 🇺🇸	1977, 1983, 1994
			Klaus Ludwig 🇩🇪	1979, 1984, 1985
			Al Holbert 🇺🇸	1983, 1986, 1987
			Rinaldo Capello 🇮🇹	2003, 2004, 2008
			Marco Werner 🇩🇪	2005, 2006, 2007
			Allan McNish 🏴󠁧󠁢󠁳󠁣󠁴󠁿	1998, 2008, 2013
			André Lotterer 🇩🇪	2011, 2012, 2014
			Marcel Fässler 🇨🇭	2011, 2012, 2014
			Benoît Tréluyer 🇫🇷	2011, 2012, 2014
			Kazuki Nakajima 🇯🇵	2018, 2019, 2020
			Brendon Hartley 🇳🇿	2017, 2020, 2022

Most Wins by Marque	Rank	Wins	Marque/Nat	Years
	1	5	Audi R8 🇩🇪	2000, 2001, 2002, 2004, 2005
	2	4	Alfa Romeo 8C 2300 🇮🇹	1931, 1932, 1933, 1934
			Ford GT40 🇺🇸	1966, 1967, 1968, 1969
			Porsche 956 🇩🇪	1982, 1983, 1984, 1985
			Audi R18 🇩🇪	2011, 2012, 2013, 2014
	6	3	Jaguar D-Type 🇬🇧	1955, 1956, 1957
			Ferrari 250 TR 🇮🇹	1958, 1960, 1961
			Matra-Simca MS670 🇫🇷	1972, 1973, 1974
			Porsche 936 🇩🇪	1976, 1977, 1981
			Audi R10 TDI 🇩🇪	2006, 2007, 2008
			Porsche 919 Hybrid 🇩🇪	2015, 2016, 2017
			Toyota TS050 Hybrid 🇯🇵	2018, 2019, 2020
	13	2	Lorraine-Dietrich B3-6 🇫🇷	1925, 1926
			Bentley Speed Six 🇬🇧	1929, 1930
			Bugatti Type 57 🇫🇷	1937, 1939
			Porsche 917K 🇩🇪	1970, 1971
			Porsche 962C 🇩🇪	1986, 1987
			Peugeot 905 🇫🇷	1992, 1993
			Porsche WSC-95 🇩🇪	1996, 1997
			Toyota GR010 Hybrid 🇯🇵	2021, 2022

LE MANS WINNING COLOURS

Constructor Wins

Rank	Wins	Constructor/Nat	Years
1	19	Porsche 🇩🇪	1970, 1971, 1976, 1977, 1979, 1981–1987, 1994, 1996–1998, 2015–2017
2	13	Audi 🇩🇪	2000–2002, 2004–2008, 2010–2014
3	9	Ferrari 🇮🇹	1949, 1954, 1958, 1960–1965
4	7	Jaguar 🇬🇧	1951, 1953, 1955–1957, 1988, 1990
5	6	Bentley 🇬🇧	1924, 1927–1930, 2003
6	5	Toyota 🇯🇵	2018–2022
7	4	Alfa Romeo 🇮🇹	1931–1934
		Ford 🇺🇸	1966–1969
9	3	Matra-Simca 🇫🇷	1972–1974
		Peugeot 🇫🇷	1992, 1993, 2009
11	2	Lorraine-Dietrich 🇫🇷	1925, 1926
		Bugatti 🇫🇷	1937, 1939
13	1	Chenard & Walcker 🇫🇷	1923
		Lagonda 🇬🇧	1935
		Delahaye 🇫🇷	1938
		Talbot-Lago 🇫🇷	1950
		Mercedes-Benz 🇩🇪	1952
		Aston Martin 🇬🇧	1959
		Mirage 🇬🇧	1975
		Renault-Alpine 🇫🇷	1978
		Rondeau 🇫🇷	1980
		Sauber-Mercedes 🇨🇭	1989
		Mazda 🇯🇵	1991
		McLaren 🇬🇧	1995
		BMW 🇩🇪	1999

Most Wins by team

Rank	Wins	Team/Nat	Years
1	13	Joest Racing 🇩🇪	1984, 1985, 1996, 1997, 2000–2002, 2006, 2010–2014
2	12	Porsche 🇩🇪	1976, 1977, 1981–1983, 1986, 1987, 1994, 1998, 2015–2017
3	7	Scuderia Ferrari 🇮🇹	1954, 1958, 1960–1964
4	5	Jaguar 🇬🇧	1951, 1953, 1955, 1988, 1990
		Toyota Gazoo Racing 🇯🇵	2018–2022
5	4	Bentley Motors Ltd. 🇬🇧	1927–1930
7	3	Matra Sports 🇫🇷	1972–1974
		Peugeot Sport 🇫🇷	1992, 1993, 2009
9	2	Ecurie Ecosse 🇬🇧	1956, 1957
		Shelby American Inc. 🇺🇸	1966, 1967
		John Wyer Automotive Engineering 🇬🇧	1968, 1969

TRACK CHANGES

Since the first race in 1923, the track has been extensively modified, mostly for safety reasons. It initially entered the town of Le Mans but was cut short to better protect the spectators. This led to the creation of the Dunlop curve and Tertre Rouge corners before re-joining the old circuit on the Mulsanne. The track is probably better known for its famous Mulsanne Straight, which is part of the RN138 – normally a public road known locally as Ligne Droite des Hunaudiéres – that now includes two chicanes. These were introduced after Roger Dorchy, in his Peugeot WM P88, was timed at 405km/h during the 1988 race.

1923-1928 17,262 km

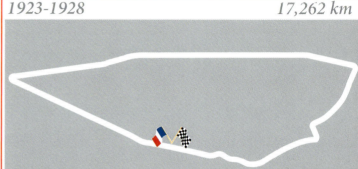

The track made up of public roads south of the city ventured into the suburbs as far as the Pontlieue Hook.

1929-1931 16,340 km

The track was shortened for safety reasons to avoid the expanding city suburbs. The new connecting road built at the expense of the ACO was called "Rue du Circuit".

1932-1955 13,492 km

The track was shortened again with a new section connecting the home straight and Tertre Rouge. The section includes the construction of the famous Dunlop Bridges.

1956-1967 13,461 km

After the 1955 accident, the entire area of the home straight was rebuilt. Track width and pit lane modifications led to a change at Dunlop curve, shortening the track by 31 meters.

1968-1971 13,469 km

To reduce the speeds after the finish straight, a chicane was created just before the entrance to the pits. Called Ford Curves, the track was directly linked to Maison Blanche.

1972-1978 13,640 km

A new section was built in the segment between Arnage and Maison Blanche, bypassing Maison Blanche completely. Joining the existing track with Ford Curves.

1979-1985 13,626 km

Due to the construction of a new public road, Tertre Rouge had to be modified, transforming the right-angled curve into a faster double curve. The second Dunlop Bridge was removed.

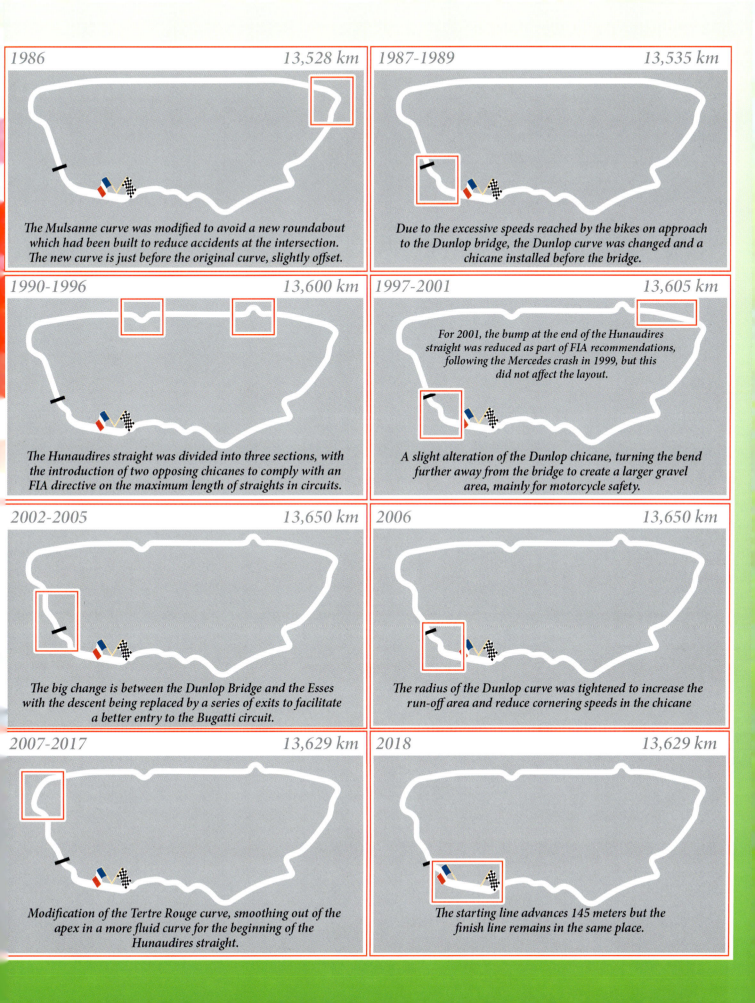

WITNESS

An apprentice mechanic in 1955, I was interested in motorsport and very much wanted to go to Le Mans. Together with my fellow apprentice Derry Aust, also a fan, we caught the ferry from Southampton and boarded a train to Le Mans. On race day the atmosphere was breathtaking, everyone trying to get a good view of the track. There was a funfair, very much like a carnival. For excited 18-year-olds it was a lot to take in, as we were just feet from the track. From our position opposite the pits at the start, we saw all the cars lining up and the drivers waiting for the flag to fall. In those days the drivers lined up on the opposite side of the track to the cars, and when the flag dropped they had to sprint across the track to get into their cars, where the handbrake had to be on and the car out of gear. Drivers would usually race off without their seat belts fastened in an attempt to get a fast start.

As the race progressed, we walked along the side of the track, stopping to take photos. About halfway round we decided to head back to the pits, walking behind the pits up to the underpass at the bottom end, opposite the grandstands. MGAs were there for the first time, so we got some photos, as they were home cars! I ran out of film, so pushing our way through the crowd to a less dense area at the back of the enclosure, I changed the film. Just as I clicked the camera shut, there was a loud bang. Turning round, it seemed most of the people who were there a minute ago had gone. There was mayhem, screaming and shouting. We saw many casualties and felt helpless, being unable to speak the language. From the news footage I think the worst would have been further up the straight. We removed ourselves from the scene and, as we were close to the exit gate, were quickly ushered out. If we hadn't gone to change the film, we would have been standing there in the line of fire. We didn't know what had happened at the time, nobody knew, as there was a lack of information at the race and after the event, especially for non-French speakers. After coming out of the enclosure, we walked on the outside of the circuit up to the Dunlop bridge and watched the race from there, still unaware of the scale of the accident. It wasn't until we got back to the old town where we were staying that we were told what had happened by the family we were staying with; even then it was very vague. On the Sunday, we phoned home to tell our families we were okay. We never really knew what had happened until we arrived home and saw the newspapers. Only then did we realise the enormity of the incident that we had witnessed.

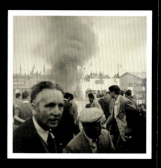

ROGER VERNON PRICE
Le Mans 1955

Driver/Nationality		Date of accident	Details
André Guilbert	🇫🇷	1925 June 19	Guilbert died after being struck head-on by a van traveling at speed on the wrong side of the road, while traveling to the race.
Marius Mestivier	🇫🇷	1925 June 20	Mestivier's car swerved on the Mulsanne and plunged into a ditch, killing him instantly.
Marcel Michelot	🇫🇷	1927 June 13	A week before the race in a late night practice he lost control of his car at Arnage and collided with an Oak tree, killing him instantly.
Pat Fairfield	🇬🇧	1937 June 19	Kippeurth lost control of his Bugatti, hitting a bank and being thrown from his car. Fairfield struck the Bugatti, Kippeurth died on the scene, Fairfield, died later in hospital.
René Kippeurth			
Pierre Maréchal	🇫🇷	1947 June 27	Maréchal spun at Arnage and rolled his Aston Martin, he died the next day.
Jean Larivière	🇫🇷	1951 June 23	Exiting the Tertre Rouge corner, Larivière lost control and was launched over a sandbank and landing in a garden, he was decapitated by a wire fence.
Tom Cole Jr.	🇺🇸	1953 June 14	Cole's Ferrari left the track, hitting several houses lining the track, he died of his injuries.
Pierre Levegh	🇫🇷	1955 June 11	Levegh died when Lance Macklin swerved to avoid Mike Hawthorn who slowed for the pits, Levegh struck the back of Macklin's car and was launched over the barrier and into the crowd.

Below are the names of those killed in this tragic accident:
Jack Diamond, Robert J. Loxley, Blanche Jeanbart, M. Languille, Louis Lapouge
Simone Malfrey, Aristide Neraud, Bernard Piermay, Daniel Pignot, Jean Poussin
Geneviève Quinton, Jean Retif, Claude Reyè, Roger Riboulin, Jean-Claude Favette
Bernard Rabot, Denise Audebert-Las Rochas, Janine Fournier, Constant Gandon
Denise Hivert, Louis Le Coze, Auguste Lebreton, M. Lepage, Jacques Marin, Gaston Neveu,
Émile Robert, Louis Rocher, Pierre Rouchy, Jacques Ruelle, Solange Travers, Henry Tual,
Marie-Isidore Vaugon, Achille Weill, Joseph Weiss, Jean-André Audebert-Las Rochas,
François Besnard, Geneviève Bichot, François Boitard, René Campion, Raymonde Cherici,
Gilbert Domer, Régine Jarry, André Lebaupin, André Leroy, François Reyé, Gérard Cornuaille,
M. Léquipe, M. De Saint-Léger, Simone Van der Eyden, Raymonde Cléricy, Geneviève Foglia,
Louis Grimault, Chantal Grellier, Josette Gouraud, Donatien Gouraud, Albert Gombert,
Roger Gauvrit, Philippe Gauvrit, M. Gauguin, Simone Fousset, Roland Fournier,
Jacques Fournier, Michel Fourey, Manuel Erausquin, Robert Émile, Fernant Gesbert,
Max Girand, Claude Gautier, Jacques Daugey, Georgette Benoist, Guy Belicot, Marcel Bergès
Roger Bridoux, Marcel Brion, Roland Brunet, Claude Brunet, Jean-Louis-Robert Delasalle
Gilbert Delabarre, Robert Divaret, Lionel Yvonnick Rousseau, 4 unknown. all spectators.

Louis Héry	🇫🇷	1956 July 28	Louis flipped his car at Maison Blanche, killing him instantly.
Jean-Marie Brussin	🇫🇷	1958 June 21	Brussin spun at the Dunlop Curve in the wet and rolled, trapped in the wreckage he was then hit by Bruce Kessler, killing Brussin.
Christian "Bino" Heins	🇧🇷	1963 June 15	While trying to avoid cars that have spun on oil from Bruce McLaren's Aston Martin, Heins lost control of his car hitting a post and exploding, killing him intantly.
Lloyd "Lucky" Casner	🇺🇸	1965 April 10	On the Mulsanne Straight Casner lost control and rolled twice and was thrown clear, but he was to die later in hospital.
Walt Hansgen	🇺🇸	1966 April 7	While testing on a wet track Hansgen lost control and drove down a slip road only to crash into a barrier placed in the slip road. He died 5 days later from his injuries.
Roby Weber	🇫🇷	1967 April 9	Weber's car crashed while taking an unscheduled lap of the track.
Lucien Bianchi	🇧🇪	1969 March 30	Bianchi suffered a mechanical failure, striking a telegraph pole, killing him instantly.
John Woolfe	🇬🇧	1969 June 23	Woolfe was killed on the first lap, being thrown from the car because he did not want to lose time fastening his seat belts due to the traditional Le Mans start.
Jo Bonnier	🇸🇪	1972 June 11	Bonnier was killed when his car touched another car, and was launched over the barriers.
André Haller	🇫🇷	1976 June 12	Haller died when his Datsun entering the Mulsanne kink spun into the guard rail.
Jean-Louis Lafosse	🇫🇷	1981 June 13	His car suddenly veered to the right crashing into a marshall's post, killing him instantly.
Jo Gartner	🇦🇹	1986 June 1	Suffering a mechanical failure Garner's Porsche hit the barrier head on at over 250km/h killing him intantly.
Sébastien Enjolras	🇫🇷	1997 May 3	The rear bodywork came loose at Arnage, making the car airborne, clearing the barriers, it exploded on impact, killing Enjolras instantly.
Allan Simonsen	🇩🇰	2013 June 22	Simonsen spun at Tertre Rouge and bounced back onto the track, he later died of his injuries.

Other Accidents/Fatalities **Driver survived

1931 June 13 Jules Bourgoin (S) Killed when Maurice Rost** crashed. 1964 June 20 James Gilbert (S) Lionel Yvonnick (S) Jacques Ledoux (S) killed when Baghetti** crashed into where they were standing. 1970 June 14 Jacques Argoud (M) killed when Jacky Ickx** crashed at the Ford Chicane.
1976 June 12 Jacques Gaston Jussien (M) Died from a heart attack. 1981 June 13 Thierry Mabillat (M) hit by guard rail when Thierry Boutsen** crashed
1984 June 16 Jacky Loisean (M) killed when John Sheldon** crashed into marshal's post.
2001 April 25 Michele Alboreto is killed while testing the Audi R8 in preparation for the 24 hours of Le Mans.

(M) Marshal (S) Spectator

ACKNOWLEDGEMENTS

I would like to thank 1992 Le Mans winner Mark Blundell for providing the foreword for this publication of the first 100 years of the 24 Hours of Le Mans.

Dean Fowler from Club Arnage for interviewing Roger Vernon Price, the 1955 crash witness, and for the information regarding track speeds.

Luis from lemans-history.com for the details regarding the track changes.

Jack from ExperienceLeMans.com for the weather information, results and figures of the class winners.

CREDITS

Motorsportmemorial.org for the facts and figures regarding the records of fatalities.

All text, content and illustrations are the copyright of Mick Hill.